IMAGES
of Aviation

FORT WAYNE AVIATION
BAER FIELD AND BEYOND

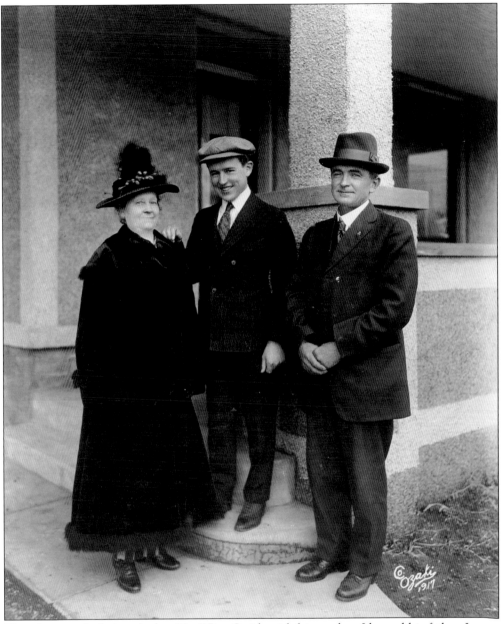

This photograph depicts Arthur "Art" Roy Smith with his mother, Ida, and his father, James, nearby the steps of their home. This still-standing house on Bass Road was Art's way of thanking his parents for the many sacrifices that they had made, which enabled him to pursue his dream of flight. Art was not a tall person, as evidenced by his standing on the step between his parents. (Courtesy of the Art Smith scrapbook.)

ON THE COVER: This photograph was taken at Sweebrock Airport. See page 42 to learn more about the Sweebrock Airport. (Courtesy of L.R. Clippinger.)

IMAGES
of Aviation

FORT WAYNE AVIATION
BAER FIELD AND BEYOND

Roger Myers, Geoffrey Myers,
Larry Myers, and Martin Kraegel III

ARCADIA
PUBLISHING

Published by Arcadia Publishing
Charleston, South Carolina

Printed in the United States of America

Library of Congress Control Number: 2011934357

For all general information, please contact Arcadia Publishing:
Telephone 843-853-2070
Fax 843-853-0044
E-mail sales@arcadiapublishing.com
For customer service and orders:
Toll-Free 1-888-313-2665

Visit us on the Internet at www.arcadiapublishing.com

*To Vonola, my wife of 62 years and counting. Her
love and support makes it possible for us to realize
many dreams in our lives. Love you, Roger*

CONTENTS

ACKNOWLEDGMENTS

During my childhood in the 1930s, I was privileged to have listened to the radio, which relayed to me stories about daring aviators of those times. The names of Eddie Rickenbacker, Jimmy Doolittle, Charles Lindbergh, Amelia Earhart, Art Smith, and Lt. Paul Baer were legends! Two of my three brothers and I served in the Army Air Corps, as did my boyhood friend Gene Klosterman. There, my interest shifted from building model airplanes to precision bombing.

I worked for a major airline at Baer Field from 1947 to 1990, observing commercial aircraft service in Fort Wayne progress from Douglas DC-3s to Lockheed Constellations, Convair CV-440s, and Douglas DC-6s to Sud Aviation SE 210 Caravelles, Douglas DC-9s, Boeing 727s and 737s, and finally to smaller aircraft flown by regional carriers. I saw the Indiana National Guard grow out of P-51s and into A-10s. Since retiring, I have supervised the Greater Fort Wayne Aviation Museum. With one of the longest runways in the United States, the Fort Wayne International Airport of today is unlike the Baer Field that I knew in the 1940s.

Many friends, several of whom are now departed, guided me toward the completion of this book. Aviation pioneers like Ellsworth Crick, Howard Emmert, and Berlen Diehm supplied me with many photographs and personal stories. Bob Schott, Bob McComb, James "Jim" Kelley, and Brig. Gen. William R. Sefton were age-group peers who shared much of the history portrayed in this book. Martin Kraegel, grandson of Jim Kelley, spent many hours cataloging the exhibits in the Greater Fort Wayne Aviation Museum. Linda Murphy, Margaret Ringenberg, and others advanced women's role in aviation.

Lou Thole, author of *Forgotten Airfields*, and William Decker, with his vast knowledge of aviation history as it pertains to Fort Wayne, are contributors. The Fort Wayne–Allen County Historical Society archives played a role too. I want to express my thanks and admiration for the work that my immediate family has contributed to this publication. My coauthors Larry and Geoff contributed countless hours editing and correcting this text. Vonola, my wife, allowed the time and freedom to see this project through.

Finally, I want express my thanks to God for his many blessings and to this great country.

INTRODUCTION

The story of Fort Wayne aviation is a story of people. Some of those people have been war heroes who sought privacy, and some have been barnstorming pilots who sought fame and fortune. Others have been successful entrepreneurs. Still others have been doing their jobs. It is also a story of cooperation between commercial aviation, general/private aviation, and military aviation and between federal, state, and local government.

Prior to 1995, Fort Wayne International Airport was known as Baer Field. Paul Frank Baer was a Fort Wayne native whose urge to fly drove him to join the Lafayette Escadrille squadron of the *Aeronautique Militaire* (French Air Service) in World War I. He became the first citizen of the United States to attain an aerial victory and ace status. When the war ended, he had a total of nine confirmed victories and seven unconfirmed victories. He was one of the first recipients of the Distinguished Flying Cross with one oak-leaf cluster. At the end of World War I, Baer remained an active pilot. After spending some time as an aeronautics inspector for the Department of Commerce, Baer traveled to Asia and was killed on December 9, 1930, when his aircraft collided with a Chinese junk on the Yangtze River in Shanghai, China. His body was ultimately shipped back to Fort Wayne. After lying in state for two days at the Allen County Court House, his funeral service was held at the Gospel Temple near the intersection of Calhoun Street and Rudisill Boulevard. His funeral procession, which was the largest in Fort Wayne history, was from the Gospel Temple through the downtown area to Lindenwood Cemetery, which was west of downtown Fort Wayne.

Arthur "Art" Roy Smith was the other famous Fort Wayne native aviator. Inspired by the accomplishments of the Wright brothers, Art borrowed $1,800 from his parents, built his own aircraft, and crashed on his first attempt at flight. Although the aircraft was nearly a total loss, he was able to salvage the engine and built another aircraft. This time he was successful, and he was soon demonstrating his flying skills throughout the Midwest and as far south as Texas. The promoters of those flying exhibitions actually paid Art for his shows, and Art was soon able to repay his loan from his parents and pay off their home. In 1915, he was invited to participate in the Panama–Pacific International Exposition in San Francisco. He demonstrated his night-flying skills by flying with phosphorus flares attached to each wingtip of his fabric-covered aircraft. At one point in that show, he performed 22 consecutive loop-the-loop maneuvers. One little known story is that when he and Aimee, his fiancée, were on their elopement flight, they crashed near Hillsdale, Michigan, and a mattress truck was serendipitously passing by. Thinking that they were dead, the truck driver loaded Art and Aimee into the back of his truck and drove them to the Smith Hotel in Hillsdale. When Art regained consciousness, he asked that a justice of the peace be summoned. Art and Aimee were married while lying in adjoining beds. When World War II started, Art volunteered to serve as a pilot, but he was turned down by the Army. Some stories say that he did not meet minimum height requirements to be a pilot; other reports say that he had suffered too many broken bones due to his many crashes. Instead, he was a civilian

pilot instructor at several training bases. He died in February 1926 near Montpelier, Ohio, when his aircraft hit a tree while he was delivering airmail. Like Baer, he was buried in Lindenwood Cemetery near Fort Wayne. In 1928, schoolchildren across Indiana collected small change to erect a monument (reported to be the tallest monument in Indiana dedicated to a single individual) in Memorial Park to honor Fort Wayne's "Bird Boy."

In the years between World I and World War II, a sequence of several airfields operated at various times. The earliest of these airfields is believed to be Flight B Field. Flight B Field was likely not much more than a flat, cleared field whose owner permitted flight operations. At some point, Capt. Floyd Showalter (the owner of Flight B Field) sold his land to Paul Holbrook. Holbrook's first student, George Sweet, and a local lawyer joined with Holbrook in the ownership and operation of Sweebrock Field. After being upgraded by the Civil Aeronautics Board (CAB), Sweebrock Field was rated as being in the top 15 of all airfields in the United States. In the late 1920s, the field was leased to Guy Means, the owner of a local General Motors automobile dealership. Between the late 1930s and the late 1940s, Myers Field was a joint venture between Lester Myers and Jim Kelley, and they operated it as a privately owned and for-profit operation.

In 1925, the City of Fort Wayne purchased land north of the city to establish a municipal airport. The airport was named Pennell Field until its name was changed to Baer Field in the 1927. The airport featured paved runways and a huge, heated Hangar Two. Over the next years leading up to World War II, Paul Baer Municipal Airport was the first airport in the nation to offer an underground fueling system and was one of the few airports to offer an area/perimeter lighting system that facilitated after-dark operations. Transamerican, Transcontinental & Western Airlines, and Capital Airways served at Paul Baer Municipal Airport. During the Great Depression, the Civil Works Administration (CWA), Works Progress Administration (WPA), and similar agencies contributed to Paul Baer Municipal Airport in the formation of improved runways, increased apron space, landscaping, improved drainage, and enhanced lighting systems.

In early 1941, with the war raging in Europe, the US Department of War approached Fort Wayne and proposed converting Paul Baer Municipal Airport into a military airfield. The city leaders counter-proposed a site southwest of the city. After raising $125,000 in private bonds, the city leased the new site to the US Army Air Corps for $1 per year. Although local residents would have preferred naming the new airfield Gen. Anthony Wayne Field or Smith Field, the Army Air Corps insisted on naming the airfield after a military aviator. The "Paul Baer" moniker became "Baer Field" when it moved to the new air base. The former Paul Baer Municipal Airport was named Smith Field. Due to strict restrictions on general and private aviation during World War II, Hangar Two at Smith Field became a densely pack warehouse of private aircraft.

Less than seven months after ground-breaking and after displacing seven family farms, the newly named Baer Field was given its first aircraft, receiving 39 Bell P-39 Airacobras on December 6, 1941, the day before the Japanese surprise attack on the naval base in Pearl Harbor and Hickam US Army Airfield in Honolulu, Hawaii. Initially, the base had about 80 buildings, three concrete runways, and aprons. Eventually, the base grew to about 120 buildings and housed several thousand troops. Ferguson Road was the primary east-west road through the base. Aircraft operations, including hangars, runways, aprons, and aircraft maintenance facilities, were generally located south of Ferguson Road. The post headquarters, barracks, theater, gymnasium, power plant, warehouses, and other facilities were generally north of Ferguson Road.

During the 1941–1945 time period, Baer Field fulfilled a number of military purposes. At some time, it was tasked with installing supplementary fuel tanks on aircraft destined for the European theater of World War II, enabling them to make the Atlantic crossing. Another role was to install the weaponry and armaments on newly built aircraft ferried in from the manufacturer. Maj. Gen. Paul L. Williams, the last military commander for Baer Field, had planned and executed several airborne and glider operations in Europe before coming to Baer Field. There is evidence that Baer Field hosted some glider and glider-towing training during the late stages of the war.

At the conclusion of World War II, the US Army Air Corps closed Baer Field and returned the facilities to the City of Fort Wayne. Commercial operations soon shifted from Smith Field to

Baer Field. Transcontinental & Western Airlines was the first to occupy the passenger terminal located on the west side of the airport. Chicago and Southern Air Lines soon began service on the routes to Detroit, Toledo, Fort Wayne, Indianapolis, Evansville, Paducah, and Memphis. By 1949, United Airlines started service to Chicago and Cleveland. The first terminal was a concrete-block building heated by a single coal-fired furnace. The local airline employees handled the typical tasks of reservations, accepted and loaded air cargo, sold tickets, checked baggage, and fueled aircraft. The military control tower was located on the north side of the field and was only operational between 6 a.m. and 10 p.m. When an inbound flight arrived or departed outside of those hours, an airline employee would drive his own vehicle around the periphery of the field to the control tower, climb several sets of external stairs, unlock a trap door, and enter the control tower to turn on the runway lights. Of course, when the flight left, this process was repeated to turn the runway lights off. During the summer months, the airline employees mowed the grass around the terminal. In the winter, they shoveled snow so passengers could reach the terminal.

Construction of a new passenger terminal on the north side of Baer Field started in 1951. The new terminal was a significant improvement over its predecessor and offered a lounge with a panoramic view of the boarding gates, a second-level outdoor observation deck, a coffee shop, a fine-dining restaurant that was a popular dining spot for local residents, ample pay-phone booths, and four ground-level boarding gates. The flight service station, weather bureau, and control tower were on the upper levels of the terminal. United Airlines, Delta Air Lines (which merged with Chicago & Southern Air Lines in 1953), and Trans World Airlines (Transcontinental & Western Air Lines) were the mainstay passenger carriers for almost 20 years. Now, the renamed Fort Wayne International Airport is served by Delta Air Lines, United Express, American Eagle Airlines, and Allegiant Air. The main terminal has been remodeled, rebuilt, expanded, and improved with four second-level jet bridges that connect passengers to their loading gates. Fort Wayne International Airport has two unique features. The first is the welcome desk that greets arriving passengers as they exit the Transportation Security Agency (TSA) screening area. This manned desk offers each arriving passenger a fresh-baked cookie and directions or information on the local area. The second unique attraction is the Greater Fort Wayne Aviation Museum, located on the upper boarding level. The museum has over 100 linear feet of display cases with sections describing Fort Wayne's early aviation history, military aviation, and airlines. The display cases also have special sections devoted to the Ninety-Nines (an association of female aviators founded by Amelia Earhart in 1929), the charter of Fort Wayne's Experimental Aviation Association Chapter Two (the second oldest chapter in the Unites States), and two large scrapbooks that Art Smith's mother kept of his exploits. The museum also displays an externally restored Curtiss OX-5 engine (used most commonly on the Curtiss JN-4D Jenny biplanes). However, the star of attraction is the full-scale replica of Art Smith's home-built aircraft that hangs above the atrium behind the TSA screening area.

Jim Kelley, one of the founders and operators of Myers Field in the late 1930s, was an important figure in Fort Wayne's aviation community. With the opening of Baer Field after World War II, his Fort Wayne Air Service moved to Hangar 48 at the field's location. Until Kelley's death in 2005, Fort Wayne Air Service was the primary fixed-base operator (FBO) at Baer Field and provided fueling, airframe and engine repair, aircraft rentals, aircraft sales, charters, flight instruction, and other services to the private aviation community. Kelley was the primary benefactor at the founding of the Greater Fort Wayne Aviation Museum, and the Kelley Foundation continues to support the museum's scholarship program.

At the end of World War II, the US Army Air Corps transferred much of its assets to the Air National Guard of the various states. In November 1947, the 163rd Tactical Fighter Squadron at Baer Field was activated under the command of Maj. William R. Sefton. The squadron started flying North American Aviation P-51 Mustang aircraft and moved into the hangars, shops, and administrative buildings on the east side of the field. The 163rd Tactical Fighter Squadron served during the Korean War. The 122nd Tactical Fighter Wing arrived at Fort Wayne, bringing in Lockheed T-33 Shooting Star jet aircraft. The airfield became the senior Air National Guard

headquarters under the control of the Indiana's adjutant general. The unit was again activated for about a year during the Berlin crisis between 1961 and 1962. Over the years, the 122nd Tactical Fighter Wing has commanded units based in Toledo, Ohio, and Terre Haute, Indiana. The unit recently converted from General Dynamics F-16 Fighting Falcon aircraft to Fairchild Republic A-10 Thunderbolt II aircraft.

One

The Ace and the Bird Boy

In the years prior to World War I, Arthur "Art" Roy Smith was the most well-known name in Fort Wayne aviation. Art Smith built his own aircraft, modeled after the Wright brothers' successful aircraft, and taught himself to fly. He mastered aerial acrobatics and was famous for his loop-the-loop skills. He was also a pioneer in night flying and often flew his fabric-covered aircraft after dark with lighted torches affixed to each wing, creating a stunning show for the spectators on the ground. Extended-exposure photographs of his aerial show in San Francisco are included in this chapter. He also made two trips to Japan to demonstrate his flying abilities, receiving many medals and much recognition while there.

The earliest airfield in Fort Wayne was known as Flight B Field. It was likely not more than an acceptable landing field. It had only rudimentary ground markings and no ground facilities. Flight B Field closed when the Sweebrock Airport opened in 1925 under the authority of the Fort Wayne Park Board. Sweebrock grew rapidly and was considered to be one of the better airports in the Midwest. The cover photograph of this book was taken at Sweebrock Airport.

When World War I began, Fort Wayne native Paul Frank Baer enlisted to fly with the French forces in Europe. Lieutenant Baer became the first US citizen to achieve ace status during World War I while he was with the French forces, and he ended the war with nine kills. In 1930, Paul Frank Baer died in Shanghai, China, when his aircraft hit a junk schooner.

Art Smith attempted to enlist with the American Expeditionary Forces under Gen. John Joseph "Black Jack" Pershing. However, he was denied enlistment either on the basis of his short stature or excessive broken bones. Art Smith was accepted as a civilian flight instructor. He died in 1926 while making an airmail flight to Bryan, Ohio.

Between the two world wars, Fort Wayne welcomed three new airfields. Guy Means Field was primarily a private airfield. Myers Field opened as a for-profit venture. However, Paul Baer Municipal Airport, on the north end of Fort Wayne, was the largest and best-equipped field. By 1930, Transcontinental & Western Airlines began services for scheduled passengers and airmail to and from Chicago, Illinois, and Columbus, Ohio.

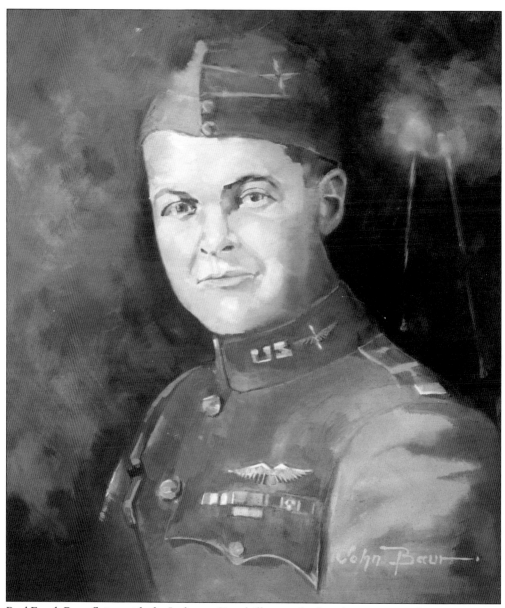

Paul Frank Baer, flying with the Lafayette Escadrille, was the first American to achieve ace status. Between March and May 1917, he scored nine confirmed kills. Baer received the Distinguished Flying Cross and the Croix de Guerre. He died in Shanghai, China, in December 1930, when his airmail aircraft collided with a junk schooner. His funeral procession started at the Gospel Temple and passed through downtown Fort Wayne. It was and still is the most highly viewed parade in Fort Wayne history. John Baur, the creator of this portrait and the portrait on the facing page, was a Fort Wayne native who painted portraits of 22 airmail pilots who died in the line of duty. The curator of the Greater Fort Wayne Aviation Museum rotates the portraits on display every month. (Painting by John Baur; photograph courtesy of Geoffrey Myers.)

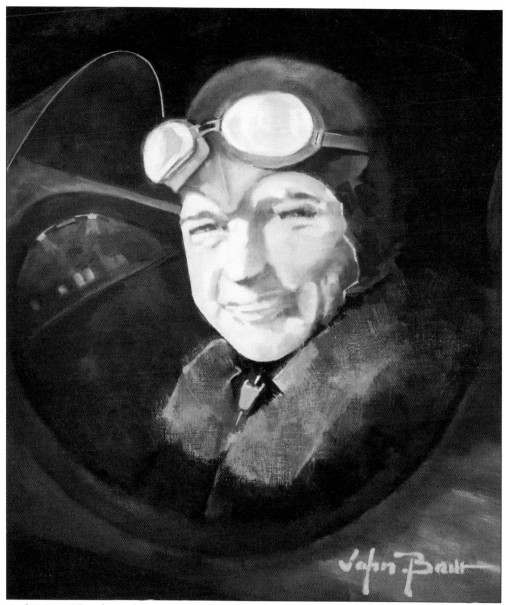

Arthur "Art" Smith was known as Fort Wayne's "Bird Boy." His boyhood dream of flight became a reality when he made his first successful flight at Memorial Park in Fort Wayne. Following a number of accidents and crashes, he rapidly attained world renown. His appearances at county and state fairs resulted in enough revenue for him to repay most of his debts and the mortgage on his parents' home. Elopement with Aimee Cour was blessed by her parents, who had hoped that the couple would wait several years before getting married. This painting, by the late John Baur, remains a prized item for the Greater Fort Wayne Aviation Museum. Although the entire John Baur collection of 28 paintings is rotated on a monthly basis, this portrait of Art Smith and the portrait of Paul Baer on the facing page are permanently displayed. (Painting by John Baur; photograph courtesy of Geoffrey Myers.)

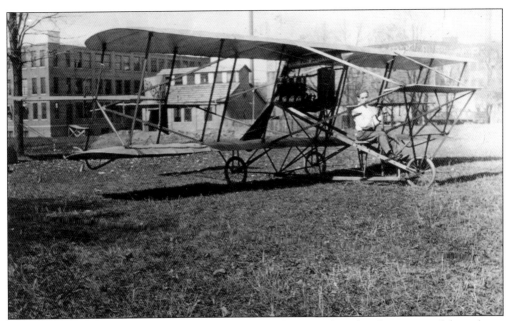

On a sunny day in 1911, Art Smith posed for this photograph in his first successful airplane. The Bird Boy took advantage of the spacious open area of Memorial Park in Fort Wayne and experimented with his airplane. He had many accidents at this location. The aircraft pictured was among the very first that he constructed with some assistance from his close friend Al Wertman. The Art Smith Memorial is near this site. (Courtesy of Smith Field files.)

Art Smith is preparing to fly his self-constructed pusher aircraft at Memorial Park in this c. 1911 photograph. He flew his aircraft in this area prior to the establishment of any airfields in Fort Wayne. The aircraft was steerable while airborne but needed human assistance on the ground because of the non-steerable nose wheel. Many of Smith's early experimental flights originated from Memorial Park. Smith had other early flights in Swinney Park, which was located on the western fringe of Fort Wayne. (Courtesy of the Art Smith scrapbook.)

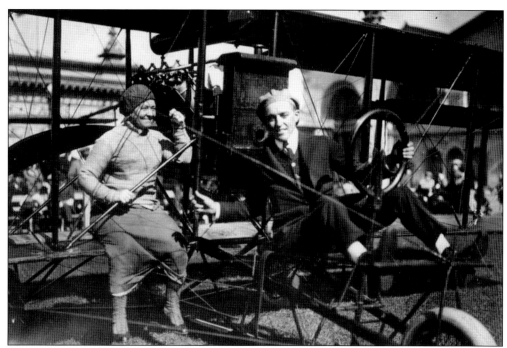

The death of aviator Lincoln Beachey prompted the leadership of the Panama–Pacific International Exposition in San Francisco to contract with Art Smith for a flying demonstration. Art was happy to sign an agreement with them, and he took his mother up in the air on two occasions while at the exposition. She wore secure apparel to reduce the likelihood of any of her garments becoming entangled. At the exposition, Art made several flights at night with fireworks attached to his aircraft. He was glowing! (Courtesy of the Art Smith scrapbook.)

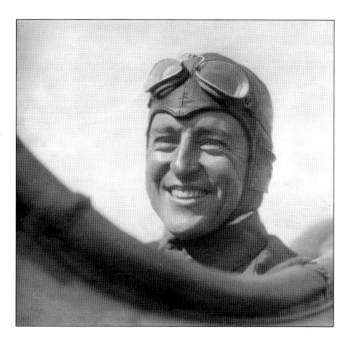

This photograph of Art Smith conveys his love for flying. Although the US Army rejected Smith's application to enlist as a pilot in World War I, Smith was a pilot instructor during World War I and served at Langley Field in Virginia, Wilbur Wright Field in Ohio, and Carruthers Field in Texas. At the conclusion of the war, Smith became a pilot for the airmail service. On February 12, 1926, he lost his life when his plane struck a tree during a snowstorm near Montpelier, Ohio. He was approaching Bryan, Ohio, during his eastbound flight. (Courtesy of Fort Wayne *Journal-Gazette*.)

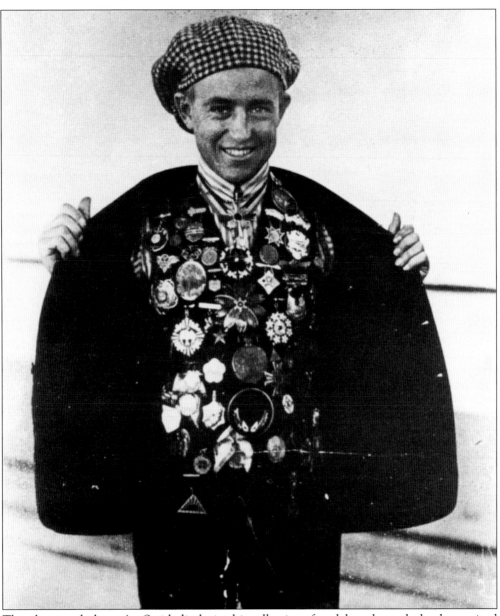

This photograph shows Art Smith displaying his collection of medals and awards that he received during his lifetime. During his two trips to Japan, he encouraged many spectators to enter the world of aviation. On his first trip to Japan, Art suffered a broken leg, which forced him to return prematurely to the United States for medical care. He then returned to Japan to complete his scheduled tour. During his tour of Japan, for which he received $10,000, he met with the Crown Prince; Prince Kuni, who was president of the Aero Society; Dr. Okuda, the mayor of Tokyo; and General Nagaoka, president of the National Aviation Association. Although offered at least $7,000 during his tour from Japanese businessmen, who wanted to purchase patents or establish an Art Smith company in Japan, he preferred flying exhibitions over becoming wealthy. (Courtesy of the Art Smith scrapbook.)

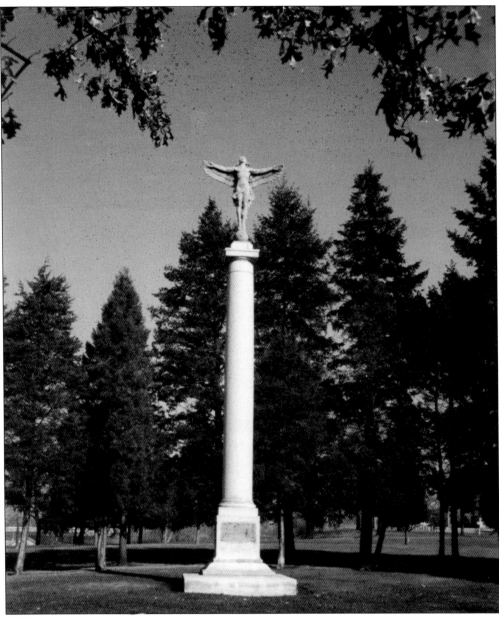

Located in east central Fort Wayne at Memorial Park, Art Smith's monument commemorated the city's "Bird Boy" and was dedicated on August 15, 1928. Civic organizations, businesses, and schoolchildren contributed funds toward this monument. He was among the first to master the loop-the-loop and once made 22 consecutive loops. He was a pioneer in the art of skywriting. At the Panama–Pacific International Exposition in San Francisco, he performed after dark with glowing phosphorus torches attached to the wingtips of his fabric-covered aircraft. The *San Francisco Bulletin* published a souvenir booklet, and the *Oakland Enquirer* filmed his night flight over the lights of the exposition. At the time of the dedication ceremony, his father, although visually disabled, read the four bronze plaques at the base of the monument, using his sense of touch. Standing more than 40 feet tall, it is the tallest monument in Indiana honoring a single individual. (Courtesy of Roger Myers.)

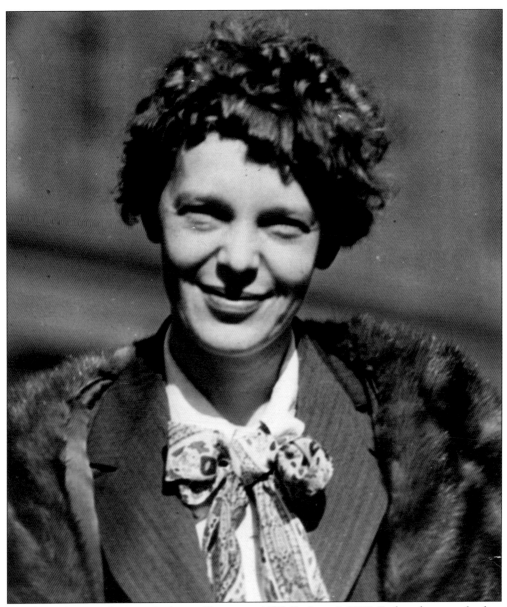

Amelia Earhart was born in Atchison, Kansas, in 1897. On June 3, 1928, Earhart became the first female passenger to cross the Atlantic Ocean by air. On May 20, 1932, the fifth anniversary of the famous Lindbergh flight, Earhart departed the Harbour Grace, Newfoundland and Labrador, Canada, and headed for the British Isles, becoming the first woman to fly solo across the Atlantic. In January 1935, she became the first pilot of either gender to pilot an aircraft from Hawaii to California. Her next venture was to attempt the circumnavigation of the earth at the equator. She and her navigator Fred Noonan departed Florida on the first leg of that journey. Her flight from the Red Sea to Karachi was the first flight from the Middle East to South Asia. The flight continued to Rangoon, Bangkok, Singapore, and Bandoeng. After flying 22,000 miles to reach New Guinea on June 29, they still had 7,000 miles remaining. Several days later, Earhart departed for Howland Island, which was the longest leg of her flight. During this leg, Earhart disappeared without a trace. (Courtesy of Ellsworth Crick.)

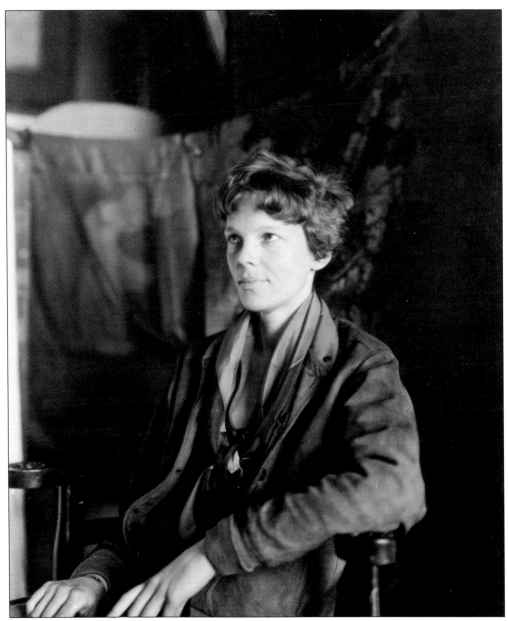

A *News-Sentinel* reporter interviewed Amelia Earhart at the Keenan Hotel on October 14, 1929, after she became the first woman to cross the Atlantic Ocean by air (she was a passenger). She planned to make that trip again as the pilot. Amelia Earhart was the first woman who made a solo round-trip across the United States and set the air speed record of 181 miles per hour. The Ninety-Nines, an international organization of female aviators that Earhart founded, currently owns Earhart's birthplace and continues to restore the home. The home contains many of Earhart's personal memorabilia and contains displays of "Earhart the Aviator" as well as displays of other female aviators. Purdue University employed Earhart to assist young women pursuing engineering degrees, particularly aeronautical engineering. The Purdue airport has a plaque that honors Amelia Earhart and has devoted space in their museum relating to her life. (Courtesy of Ellsworth Crick.)

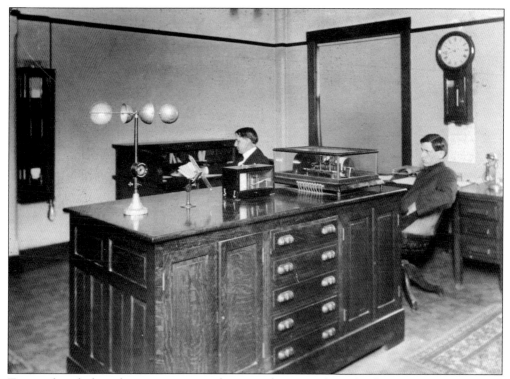

Two unidentified employees monitor conditions at the original weather bureau office in an upper floor of the Shoaff Building in 1912. A wind velocity indicator is on the desk to the left, and a recording barometer is to the right. During World War II, the bureau relocated to the Paul Baer Field, near Hangar 38. Following the construction of the new passenger terminal in the early 1950s, it relocated to the second floor. (Courtesy of Fort Wayne International Airport.)

Meteorologist B.B. Whittier checks the precipitation-collection equipment at the weather station on top of the federal building on Harrison Street in this c. 1937 photograph. During World War II, the weather bureau moved to the Baer Army Air Base. Modern technology enables pilots and the public to obtain weather information through several networking media. (Courtesy of US Weather Service.)

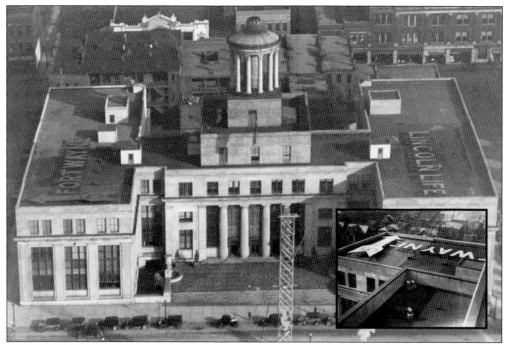

Navigation of airplanes from their origins to their destinations sometimes relied on visible markings on the terrain, buildings, or rooftops. This aerial view of the main offices of the Lincoln National Life Insurance Company building, which was located on South Harrison Street, clearly shows the name of the business and an arrow that pointed north. The arrow in the picture points to the direction of the Paul Baer Municipal Airport. Rooftop and water tower messages are still in use, but mostly for advertising purposes. (Courtesy of Fort Wayne History Center.)

Prior to 1926, none of the area airfields had designated runways or other navigational aids and indicators. To compensate for this and to assist pilots in locating the field, there was a 100-foot-diameter chalk circle that made the field more clearly visible. A straight chalk line perhaps 500 feet in length would mark the preferred direction for the landing approach. (Courtesy of Ellsworth Crick.)

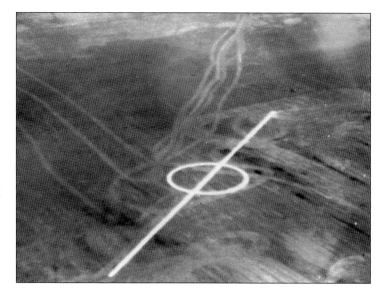

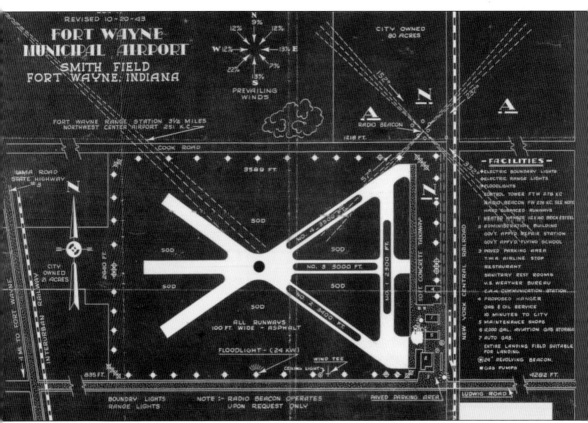

This blueprint of Fort Wayne Municipal Airport shows the runway layouts, floodlights, and location of the radio ranges. Perimeter floodlights provided lighting for the entire airfield. However, complaints by local residents and some pilots ended this lighting system. A few years later, the center runway was deactivated and demolished. Over the years, the airport's use was minimal in comparison to the Baer Army Air Base, which opened in 1941. Until about 1950, an interurban rail line ran along the east perimeter of the field, creating a multi-modal terminal. Renewed interest in general aviation during the 1990s caused a revival of activity at Smith Field that has resulted in runway and taxiway improvements, increasing the field's hangar availability. Ivy Tech Community College students can receive aircraft maintenance training at this facility, which further enhances the importance of this historic airport. (Blueprint courtesy of Alfred Allina from Smith Field files.)

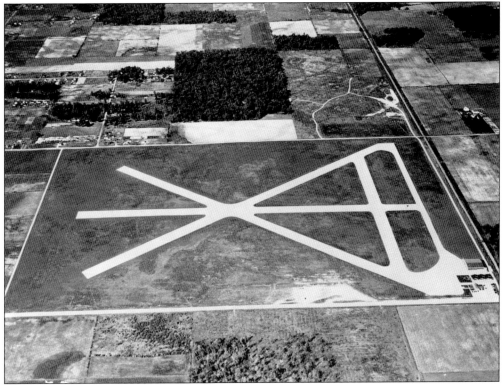

This aerial photograph of the original Paul Baer Municipal Airport (now known as Smith Field) shows the interurban rail line passing to the east of the field. The airport was between Ludwig and Cook Roads. The center runway in the photograph is no longer active. The beacon tower was not yet built. (Courtesy of the *News-Sentinel*.)

This is an aerial view of the Paul Baer Municipal Airport, which later became Smith Field, showing the historic hangar, airway's rotating beacon, and a commuter train about to cross Ludwig Road. The hangar is still in use today and is in the National Registry of Historic Places. (Courtesy of Ellsworth Crick.)

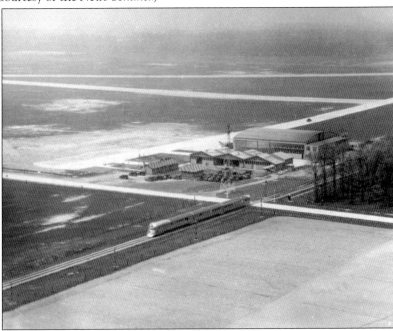

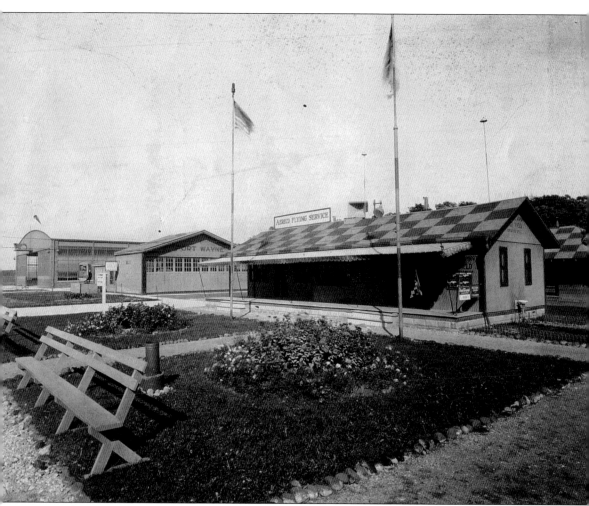

Paul Baer Municipal Airport thrived and grew in the 1930s. The Aereco Flying Service building is visible in the foreground. The large hangar to the left background of this photograph is the main hangar and is still in service. The T-hangars are between the Aereco building and the main hangar. Near the middle building, one of the three floodlights, which once lit the entire airfield, is visible. A closer view of this floodlight is on page 30. In the right foreground of this photograph appears to be a locomotive bell on a pedestal, the building roof that supports a floodlight, and a speaker that announced arrivals and departures. In front of the terminal stand two flagpoles, and the rear pole has the American flag. The secondary windsock is on the top of the main hangar. During the winter, the flowerbeds became ice-skating rinks. (Courtesy of Smith Field files.)

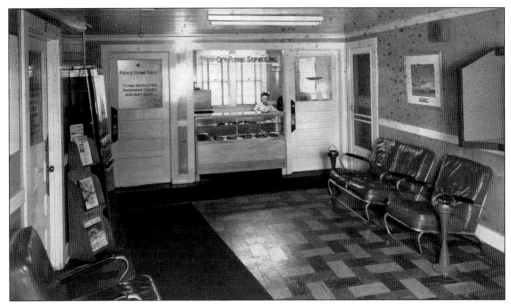

The passenger lobby of Paul Baer Municipal Airport housed Pierce Flying Service (left) and another tenant in 1938. Adjoining this lobby was a room that contained several bunks to accommodate fliers whose flights may have been running late. The administration building contained several tables, chairs, and an attended snack bar. Transcontinental & Western Airlines (T&WA) was the only scheduled airline at this time and ran one flight each day to and from Chicago. (Courtesy of Fort Wayne International Airport.)

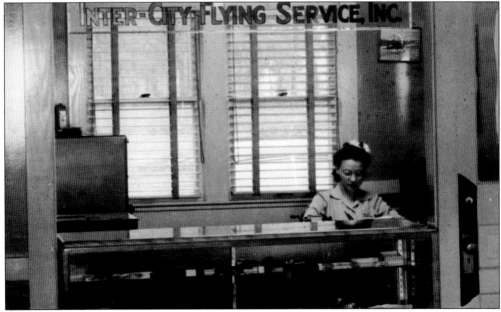

Adjacent to the lunchroom at the Paul Baer Municipal Airport was a very small gift shop operated by the Inter-City Flying Service. Most of the display includes various goggles and sunglasses. The single-engine aircraft in the framed picture in the background appears to be one of the Sky Roamers that were designed and constructed by Paul Hobrock in Fort Wayne, Indiana. This aircraft photograph was probably not for sale. (Courtesy of Smith Field files.)

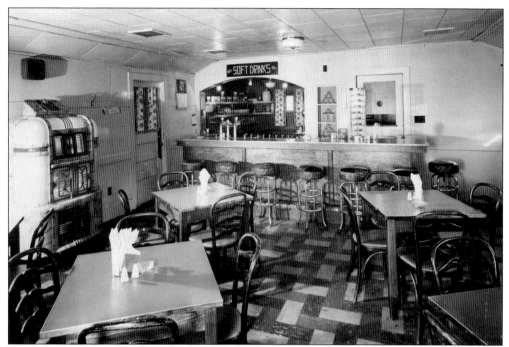

This is a 1930s photograph of the restaurant at the Paul Baer Municipal Airport, which is now known as Smith Field. Although the room appears quite small, at least 27 seats are available for the customers. The massive machine to the left is a jukebox that would play recorded music for 5¢ per song. Soft drinks were only 10¢ each! (Courtesy of Smith Field files.)

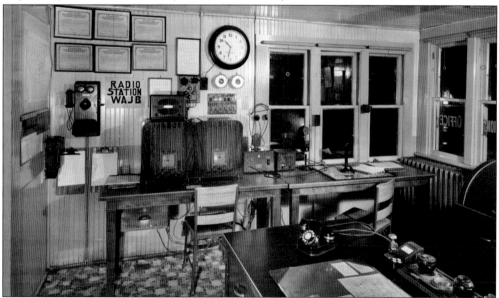

Paul Baer Municipal Airport's Hangar Two had a communications room that provided air-to-ground voice communications. Some of the equipment shown in this photograph was from the US Army Air Corps and was distributed as surplus. The frames on the wall contained license certificates and permits pertaining to the operation of the radio equipment. (Courtesy of Smith Field files.)

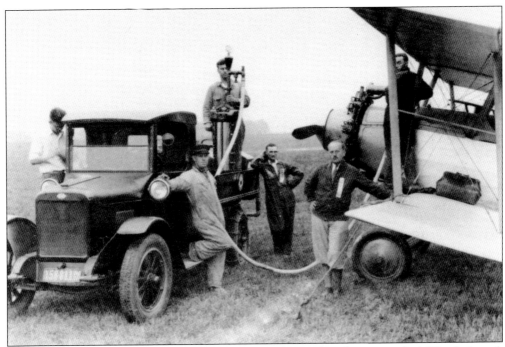

A fuel truck at Paul Baer Field services a commercial aircraft with aviation fuel. The fuel truck bears the logo of International Harvester, which confirms that it was manufactured in Fort Wayne. The license plate bears a date of 1926. The pump assembly is not entirely visible and is probably a product of the Wayne Pump Company of Fort Wayne. (Courtesy of Smith Field files.)

The Bowser Pump Company of Fort Wayne developed a ramp fueling pump. This system replaced the vehicle-dependent system pictured above. A similar system was to be built at the Paul Baer Field West Terminal in the late 1940s. The author recalls airline executives visiting Fort Wayne to observe the new system in the late 1940s. (Courtesy of Smith Field files.)

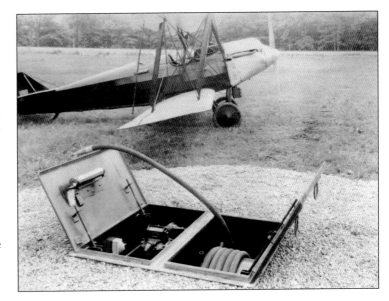

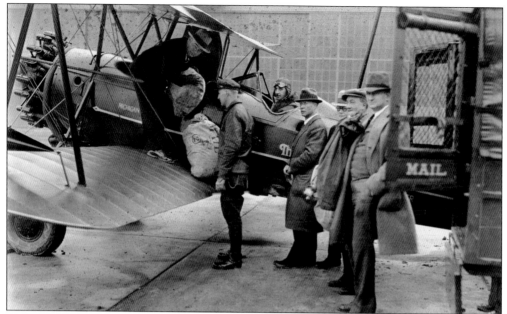

An executive of Thompson Aeronautical Corporation loads the first airmail from the Paul Baer Municipal Airport. Looking at this historical event are, from left to right, George Bohnstedt, George Hill, G.J. Gladbach, Ben F. Byers, Fred Brown, and John Erwin. Hill made three round-trips to South Bend from Fort Wayne on that date, carrying a surprisingly large load of commemorative mail. (Courtesy of Thompson Aeronautical Corporation.)

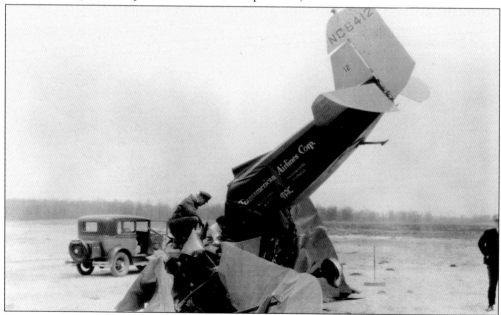

The first aviation fatality at Paul Baer Municipal Airport occurred on April 21, 1932. Lt. George Hill, a pilot for Transamerican, was returning from his regular daily flight from South Bend with the US airmail. The weather was clear with nearly calm winds. Witnesses say that while nearing midfield at 700 feet, the aircraft just plunged straight down, killing Hill instantly. (Courtesy of Smith Field files.)

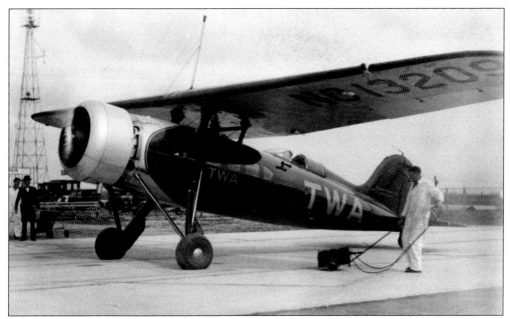

This single-engine aircraft operated by Transcontinental & Western Airlines (T&WA) is typical of the aircraft serving Paul Baer Municipal Airport in the early 1930s. Note the entirely closed passenger cabin and the fully exposed open cockpit at the rear of the cabin. The mechanic is positioning a portable battery used to start most aircraft during that era. (Courtesy of Smith Field files.)

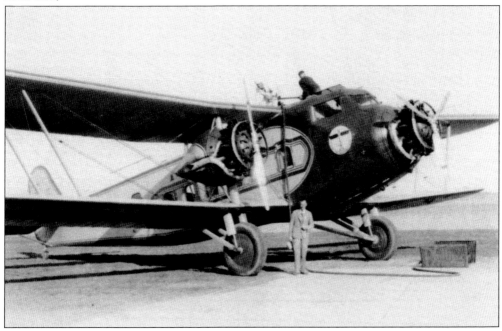

Mike Murphy from Findlay, Ohio, owned this early-1930s Boeing 80A Tri-Motor. The Fort Wayne–based Bowser Company's underground-ramp fueling system replenishes this aircraft at the Paul Baer Municipal Airport. This Boeing aircraft was highly competitive with the Ford Motor Company's more famous single-wing Ford Tri-Motor aircraft. (Courtesy of Smith Field files.)

Robert Bartel, the manager of Paul Baer Municipal Airport in the 1930s, stands by one of three floodlights that provided general illumination to the entire field. These powerful floodlights were on the east, south, and west boundaries of the airport. At this time, Paul Baer Municipal Airport was one of only a few illuminated airports in the country. (Courtesy of Fort Wayne International Airport.)

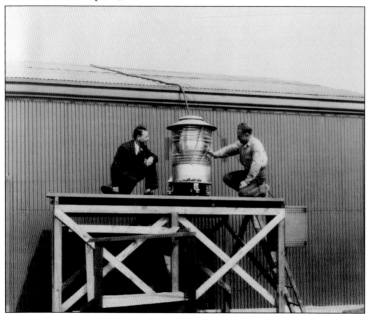

Two unidentified men inspect a boundary light located near a hangar at Paul Baer Municipal Airport in the late 1920s. The blueprint on page 22 shows similar lights positioned around the periphery of the field. This appears to be a temporary installation. (Courtesy of the *News-Sentinel*.)

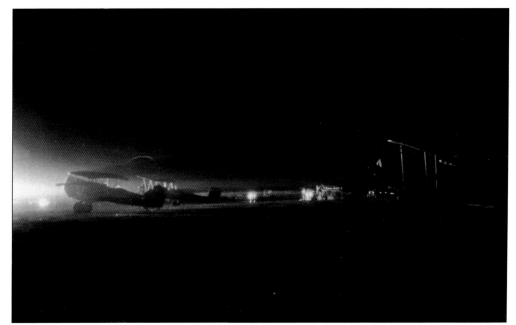

This dramatic photograph shows the effectiveness of the lighting system at Paul Baer Municipal Airport. Because most of the aircraft did not have their own lights, this lighting system allowed rudimentary night operations. This photograph of an arrival appears to have been taken looking eastward along the southern edge of the field, where some buildings are visible in the distance. (Courtesy of Smith Field files.)

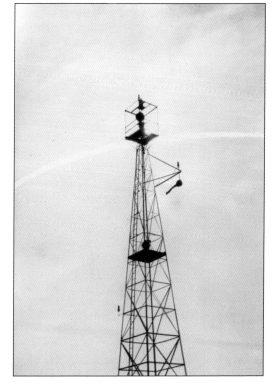

In 1926, the original Paul Baer Municipal Airport had a beacon tower that measured 85 feet in height. The tower also included a windsock. The airport moved the beacon north about 100 yards from the southeast corner of the field to a location near Hangar Two, which permitted adequate runway clearance. (Courtesy of Ellsworth B. Crick from the collection of James and Joyce A. Butler.)

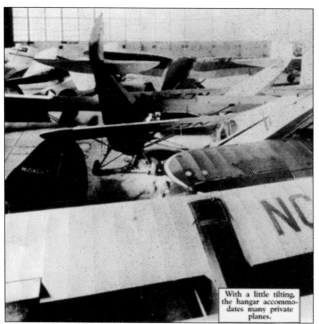

During World War II, Hangar Two at Smith Field stored and secured numerous disabled private aircraft for the duration of the war. This photograph shows some of the aircraft in Hangar Two in a nose-down configuration, which allows for maximum use of the limited space. During World War II, all private aircraft owners had to remove either their aircraft's engines or the wings. (Courtesy of Smith Field files.)

With a little tilting, the hangar accommodates many private planes.

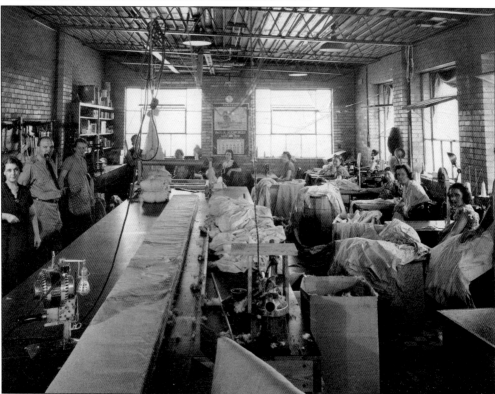

During World War II, the upper level of Hangar Two at Smith Field (formerly Paul Baer Municipal Airport) hosted a business that produced the tow targets for use in aerial gunnery training and target practice. Paul Hobrock is visible on the left, wearing the necktie. The long cutting table and two electrical fabric scissors are visible in the left foreground. (Courtesy of Smith Field files.)

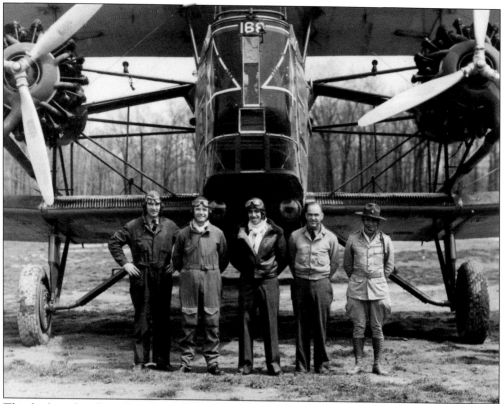

This biplane bomber, thought to be a Martin MB-1, visited Paul Baer Municipal Airport and parked north of the main hangar around 1928. Although this photograph is well known among Fort Wayne aviation buffs, the crewmembers have never been identified. (Courtesy of James and Joyce A. Butler; captioned by Robert [Bob] McComb.)

This image shows the same Martin MB-1 in the other photograph on this page. The bombardier performed his duties behind the small windows at the bottom of the nose. Notice the large balloon tires that allowed operation on sod and mud fields. The crewmember standing on top of the fuselage is wearing his parachute, which probably doubled as a seat cushion. (Courtesy of Smith Field files.)

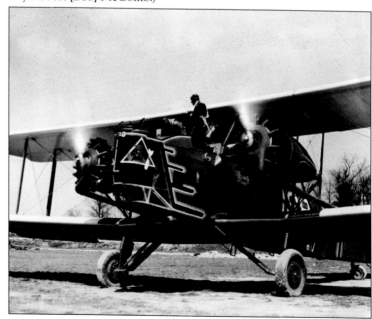

Seven distinguished gentlemen stand near an aircraft in front of Hangar Two at Paul Baer Municipal Airport. Holding his white hat, Harry William Baals, who was the mayor of Fort Wayne (1934–1947 and 1951–1954), is the third person from the left. The identities of the other six gentlemen are unknown. The aircraft behind them appears to have a two-way radio and possibly direction-finding equipment. (Courtesy of Smith Field files.)

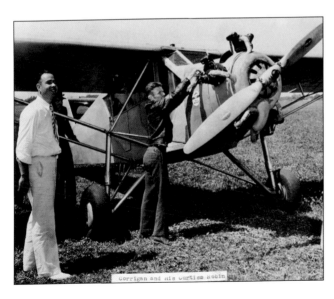

Corrigan and his Curtiss Robin

Douglas "Wrong Way" Corrigan performs preflight checks on his Curtiss Robin at Paul Baer Municipal Airport while Robert Schott, a *News-Sentinel* aviation writer, looks on. Corrigan made an unauthorized transatlantic flight on July 17–18, 1938. He planned to travel from Floyd Bennett Field in Brooklyn, New York, to Long Beach, California, but instead landed in Baldonnel Aerodrome, a military airbase in Dublin, Ireland. Corrigan toured a number of cities in the United States following his epic flight. (Courtesy of *News-Sentinel*.)

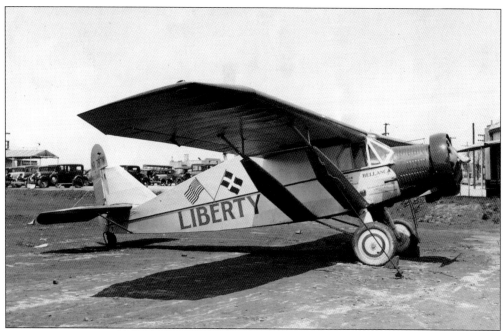

In April 1931, Otto Hillig and Holger Hoiriss parked their Bellanca aircraft (tail number NR797W) at Paul Baer Municipal Airport while preparing to attempt a flight from Newfoundland, Canada, to Copenhagen, Denmark, in May. The rear of the passenger compartment was converted to fuel storage to increase the aircraft's range. (Courtesy of James and Joyce A. Butler.)

At first glance, this aircraft appears to be a Ford Tri-Motor, but it is a Boeing B-80A. This aircraft (tail number 2243) was owned by the Detroit–Grand Rapids Airline and provided service to Paul Baer Municipal Airport in the late 1930s. The owner of the fuel truck, Lassus Brothers Oil, Inc., is still in business today. (Courtesy of James and Joyce A. Butler.)

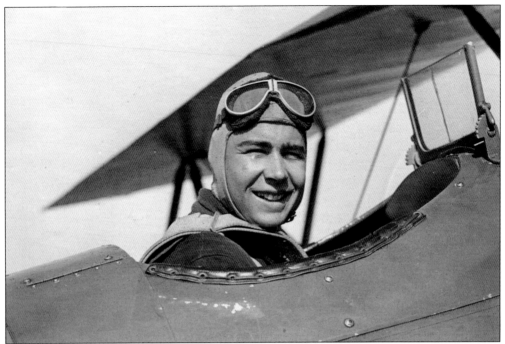

Robert Schott was among the early pilots who supported the growth of aviation in northeast Indiana. He was the copyboy for Oscar Foellinger, publisher of the *News-Sentinel*. During World War II, Schott was the manager at Paul Baer Municipal Airport, and he remained in aviation for many years. He was among the founders of the Greater Fort Wayne Aviation Museum. (Courtesy of *News-Sentinel*.)

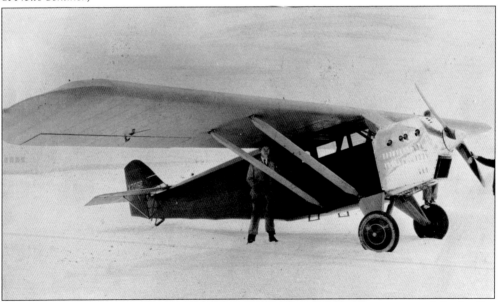

Oscar Foellinger, the first newsman in Indiana to use an aircraft to track stories, stands by the Sky Roamer owned by the *News-Sentinel*. At the time, Foellinger was the owner of the *News-Sentinel*. This Sky Roamer was one of only two aircraft built by Paul Hobrock of Fort Wayne. (Courtesy of the *News-Sentinel*.)

Gene Rock and Clarence B. Cornish (in cockpit) prepare for a flight in which Rock would make a parachute jump. Cornish served in World War I as a pilot and returned to service in World War II. He was also the first aviation commissioner in Indiana. Gene Rock, who made his living jumping from perfectly airworthy aircraft, is wearing both a primary and secondary parachute. (Courtesy of Clarence Cornish family.)

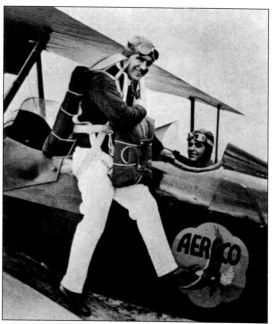

Lt. George Hill flew the first mail from Fort Wayne to South Bend on December 9, 1930. Hill died on April 22, 1932, when his biplane crashed at Paul Baer Municipal Airport while returning from South Bend. At the dedication of the Smith monument, Hill was one of the pilots who dropped a wreath near the monument. (Courtesy of Fort Wayne International Airport.)

In 1930, Earl Miller checks in Clyde Shockley (in cockpit) at the Fort Wayne check-in point of the air tour. These air tour flights were normally flown on Saturdays by aircraft owners and operators. The flights typically left Paul Baer Municipal Airport and flew to other area airports before returning. (Courtesy of *News-Sentinel*.)

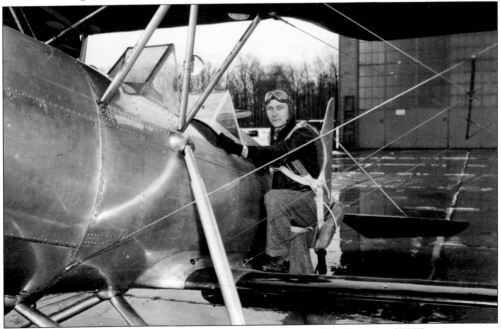

James "Jim" Kelley was among the first to enroll in the Civilian Pilot Training (CPT) program prior to World War II. Pres. Franklin D. Roosevelt started the CPT program to produce more pilots. Here, Kelley preflights a CPT aircraft. Kelley devoted much of his time and resources toward the advancement of aviation in Fort Wayne and surrounding area. (Courtesy of the Kelley family.)

Aviatrix Thelma Kennedy poses between two unidentified women in July 1938 at Paul Baer Municipal Airport. The Indiana Air Tourist Company operated sightseeing flights for adventuresome citizens of Fort Wayne and other northeastern Indiana communities. These ladies are wearing their Sunday best. (Courtesy of James and Joyce A. Butler.)

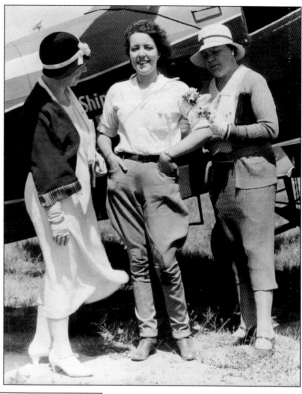

Thelma Kennedy (right) and an unidentified woman are pictured on a sodden section of the original Paul Baer Municipal Airport in 1938 with their tour director from Indiana Air Tourist Company. While the type of aircraft cannot be conclusively determined in this photograph, the leather helmets and goggles suggest that the aircraft was open-cockpit. (Courtesy of James and Joyce A. Butler.)

Ellsworth B. Crick photographed himself piloting a glider over the vicinity of Guy Means Field. Guy Means purchased and renamed the Sweebrock airfield northwest of Fort Wayne near the current site of Glenbrook Shopping Center. An automobile towed Crick's glider into the air. Once airborne, Crick would disconnect the towline. (Courtesy of Ellsworth Crick.)

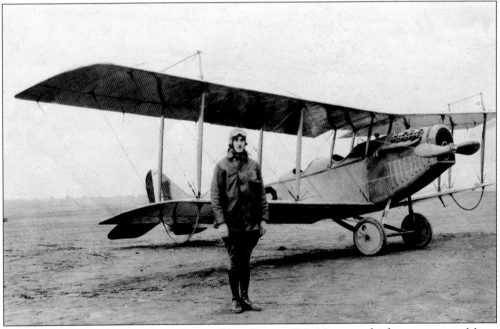

An unidentified pilot stands in front of his Curtiss JN-4 Jenny, which was powered by a 100-horsepower OX-5 engine, at Guy Means Field. The OX-5 engine in this aircraft is the same type as displayed by the Greater Fort Wayne Aviation Museum in the Paul Baer terminal at the Fort Wayne International Airport. (Courtesy of OX-5 Aviation Pioneers.)

40

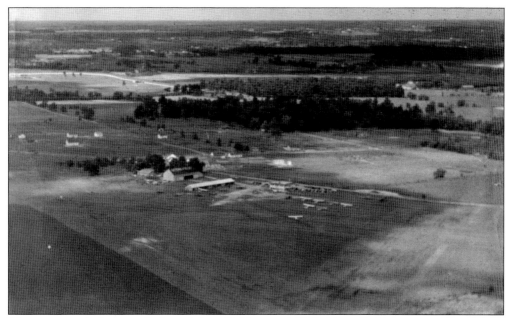

This rare aerial photograph shows Myers Field around 1940. Myers Field was a joint venture by Lester Myers and James "Jim" Kelley, using farmland and a remodeled farmhouse that provided living and office space for both the Myers and Kelley families. Myers Field was an active CPT training site near Wayne Trace in southeast Fort Wayne. The CPT program provided government-sponsored flight training to civilians. (Courtesy of the Kelley family.)

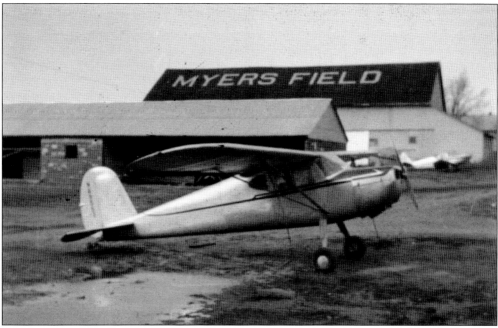

A high-wing aircraft sits amid mud puddles at Myers Field in the late 1940s. Lester Myers and James "Jim" Kelley had developed this sod airport in the 1940s from farmland located on the west side of Wayne Trace in southeast Fort Wayne. Myers and Kelley remodeled the existing farmhouse into a duplex and lived with their families on-site for several years. (Courtesy of the Kelley family.)

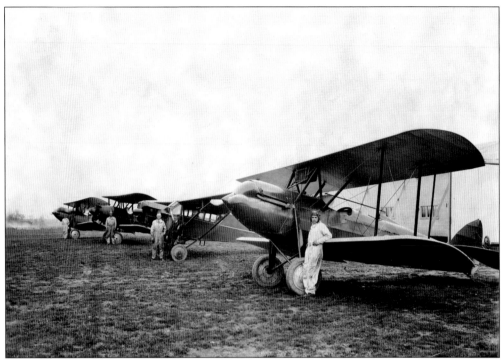

This photograph of Sweebrock Airport shows its location on the northern fringe of Fort Wayne, near Lima Road. Aereco Flying Service pilots shown are, from left to right, Warren Ashley with his Waco 10; Kenneth Siebert with his Waco, which was powered by a German Seimens-Halski 125-horsepower engine; Capt. Clarence Cornish and Red McVey with their Curtiss Robins, which was powered by an OX-5 engine; and E.W. "Gene" Campbell with his Waco 10, which was also powered by an OX-5 engine. (Courtesy of L.R. Clippinger.)

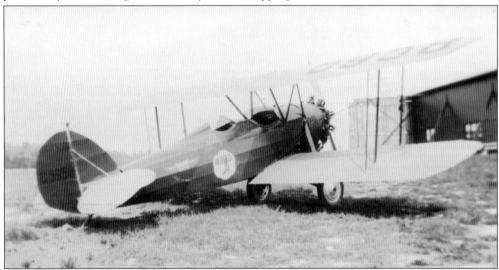

Aereco Flying Service owned this Waco tail-dragger biplane at the Sweebrock Airport in the late 1920s. Aereco Flying Service operated the 125-horsepower aircraft for sightseeing flights and other short hops. Sweebrock was a privately owned airport that closed when Paul Baer Municipal Airport (now Smith Field) opened. (Courtesy of James and Joyce A. Butler.)

Two

SEVEN-MONTH MIRACLE

In January 1941, the US War Department approached the City of Fort Wayne to negotiate the use of Paul Baer Municipal Airport as a military base. The city leaders proposed a 608-acre site on the southwest side of the city and suggested the name "Wayne Army Air Corps Base." But the US Army Air Corps insisted that the base should be named after a military aviator, and it was named Baer Field. Shortly afterward, the former Paul Baer Municipal Airport was renamed Smith Field.

After moving seven families with their homes, their farming equipment, and their livestock, construction on Baer Field began in late 1941. The initial configuration included three runways and over 82 buildings. Local and regional construction firms did most of the construction. For most of the war, Paul Baer Field was part of the Troop Carrier Command but performed a variety of missions. Over time, the troops at Paul Baer Field installed temporary auxiliary fuel tanks in perhaps 1,500 aircraft to enable them to make the flight across the Atlantic Ocean. The photographs in this chapter show that virtually every aircraft in the Army Air Corps inventory made at least a visit to Paul Baer Field.

Life on Paul Baer Field was similar to many other US Army Air Corps bases. The south side of Ferguson Road hosted the runways, taxiways, aprons, hangars, maintenance buildings, and other flight support activities. The barracks, gymnasium, chapel, theater, hospital, power plant, and various headquarters and offices were located on the north side of Ferguson Road.

The *Beacon* was the official base newspaper. The 170 issues covered official announcements, listings of current events and activities, and often some rumor-control items.

The last commander of Paul Baer Field was Maj. Gen. Paul L. Williams. Major General Williams had served in Europe and had planned many airborne and glider operations. At the time, he was recognized as being perhaps the US Army Air Corps' best air-insertion expert.

At the conclusion of World War II, the US Army Air Corps sold the buildings and equipment on Paul Baer Field to the City of Fort Wayne for $1. Only two of the original World War II buildings, Hangars 39 and 40, survived to 2011.

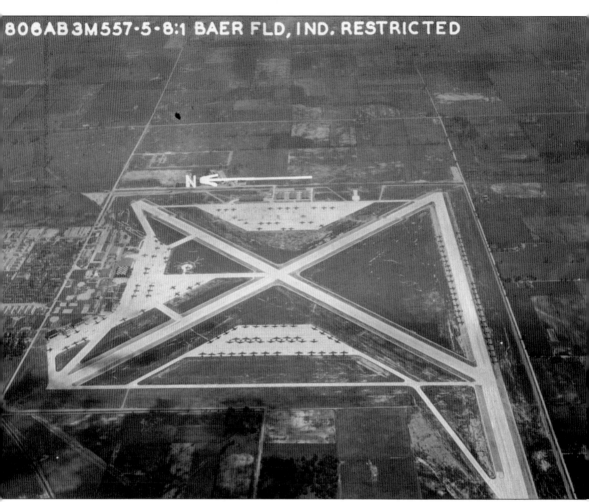

Hundreds of Curtiss-Wright C-46 Commando and Douglas C-47 Skytrain aircraft line the inactive runways and fill most of the available ramp spaces. This view is looking toward the east. The post's headquarters, barracks, theater, gymnasium, maintenance shops, base exchange, warehouses, and other administrative buildings are on the left side of this photograph. Ferguson Road, the primary east-west road, is also on the left side. Barely visible, a railroad line runs horizontally just below the north arrow on this photograph. Several years later, the first commercial terminal would be built on the apron in the foreground (bottom) of this photograph. The troops at Paul Baer Field added additional fuel tanks and oil reservoirs to enable these aircraft to make the Atlantic crossing for deployment during the operations in the European theater of World War II. Thousands of soldiers passed through Paul Baer Field between 1941 and 1946. (Courtesy of CWO Harry Smith.)

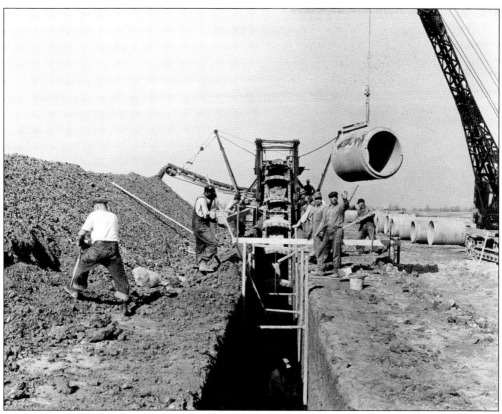

Cooke Construction did much of the drainage pipe emplacement prior to the activation of Baer Field in 1941. This photograph shows an excavator digging what appears to be an eight-foot-deep trench. The white structures in the foreground are rudimentary braces to prevent the sides of the excavation from collapsing into the trench. The absence of hard hats or other safety equipment bespeaks the urgency of the work. (Courtesy of Paul Baer Air Base files.)

On July 16, 1943, several men are working to improve the roadway near the Twelfth Street barracks. In accordance with World War II construction standards, the construction team is employing mixed-in-place paving techniques using expedient materials. The trailer on the right side of the photograph is melting pitch that will be sprayed onto a foundation of gravel and sand. (Courtesy of CWO Harry Smith.)

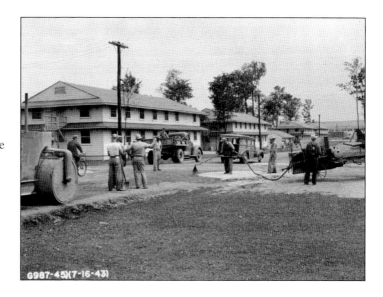

Moellering Construction Company completed the Butler Hangars and the surrounding taxiways on the east side of Baer Field in 1943. The area, known as the "Sub Depot," retrofitted Europe-bound aircraft with augmented fuel and oil capacity. The small arms practice range was nearby. The Butler Hangars are now gone, and the Indiana Air National Guard has erected several buildings and hangars on the site. (Courtesy of Paul Baer Field.)

In 1943, Moellering Construction Company worked to complete two Butler Hangars and the surrounding aprons. Because regular cement was in short supply, soil cement replaced concrete as the primary construction material. Soil cement was a mix of cement and ashes from the City Light & Power Company. In later years, this substitute mix caused problems with heavier aircraft. (Courtesy of the US Army Corps Engineers.)

Couse and Sanders built the apron on the north side of the field. This photograph, taken from the top of the military control tower toward the northwest, shows Ferguson Road running from left to right. The building in the foreground is probably the office for one of the construction contractors. Because this was a temporary structure, minimal effort was made to improve the dirt parking area surrounding it. A small city of standard World War II barracks and other buildings is seen just beyond, to the north of Ferguson Road. Note the absence of grass and landscaping among these structures. A civilian barn and some private homes are barely visible just below the horizon. Those buildings were outside of the fence line of Paul Baer Field Army Air Base. Neither the buildings nor the barn exist today. (Courtesy of CWO Harry Smith.)

The main hangar was under construction in 1941. Construction was via manual labor provided mostly by citizens of the local area. The control tower was in operation at this time, and the image shows the rudders of a Martin B-26 Marauder that occupied the almost-finished hangar. (Courtesy of Paul Baer Field files.)

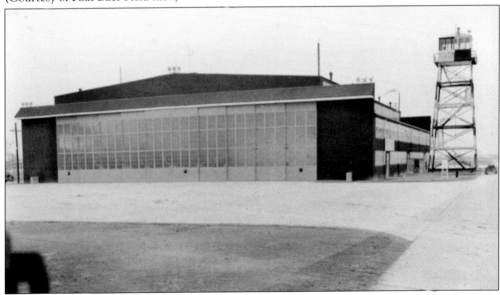

The construction company W.A. Sheets & Son, Inc., was the prime contractor on the main hangar in 1942. Fire destroyed this large building in 1946. The control tower survived the fire and continued in service until 1953. During the Eisenhower administration, the tower operated from 6:00 a.m. to 10:00 p.m. During those years, airline personnel climbed the tower during off hours to turn the runway lights on and off. (Courtesy of CWO Harry Smith.)

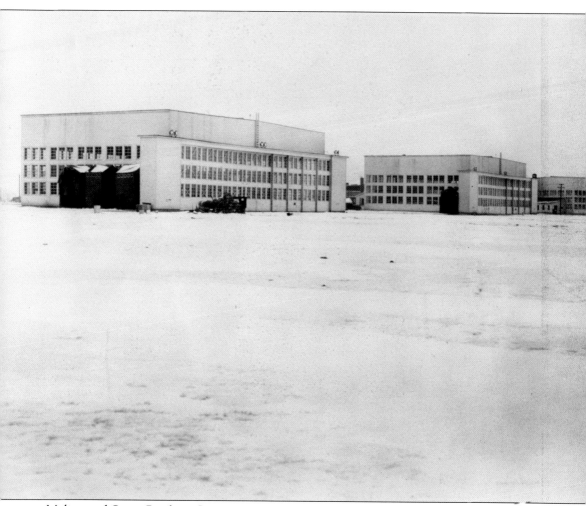

Moline and Seiter Brothers Construction Company completed these hangars in mid-1942. In addition to servicing aircraft, the hangars also periodically hosted United Service Organization (USO) shows that would bring Hollywood film stars to the base for the enjoyment of the soldiers. Among the better-known performers who visited the base was Judy Garland. The extensions on both sides of the main door allowed the entire front of the hangar to open for the movement of aircraft. Because steel was a strategic material, wood replaced virtually all of the steel in these large buildings. At the rear of the far right hangar, a small attached coal-powered utility building can be seen. Two of the hangars remained as Buildings 39 and 40, with Federal Express, Atlantic, and the fixed-base operator (FBO) as tenants. Those tenants modernized these hangars with improved siding, lighting, and modern office equipment. (Courtesy of CWO Harry Smith.)

In 1944, Ferguson Road was the primary east-west road through the airport complex. The small building on the right side of the photograph is the post fire station, whose location north of the airfield and south of the administrative and billeting area permitted timely response to emergencies throughout the base. The post flag is visible beyond the fire station; the base headquarters was across the street. (Courtesy of Fort Wayne International Airport.)

The west gate on Ferguson Road was a secondary entry point to Baer Field from 1941 to 1945. Later, the guardhouse at this location operated 24 hours a day. A chain-link fence topped with barbed wire surrounded the base to discourage would-be intruders. In the mid-1970s, a runway extension forced the rerouting of this portion of Ferguson Road. (Courtesy of Fort Wayne International Airport.)

Maj. Gen. Paul L. Williams was the commanding general of the Troop Carrier Command (TCC) and Baer Army Air Base at the conclusion of World War II. He was the sixth and last commanding officer at Baer Army Air Base. His five predecessors had been colonels and brigadier generals. Major General Williams came to Baer Army Air Base from the 9th TCC in Europe, where he was responsible for more than 1,000 Douglas C-47 Skytrains and 900 gliders in the Normandy invasion on D-Day. After leaving the TCC, Major General Williams served as the commanding general of the Third Air Force, Ninth Air Force, Second Air Force, and Tenth Air Force. A native of Detroit, Major General Williams served his country for more than 33 years and became known as one of the Air Force's most effective airborne operations technicians. He died on March 1, 1968. (Courtesy of Baer Army Air Base files.)

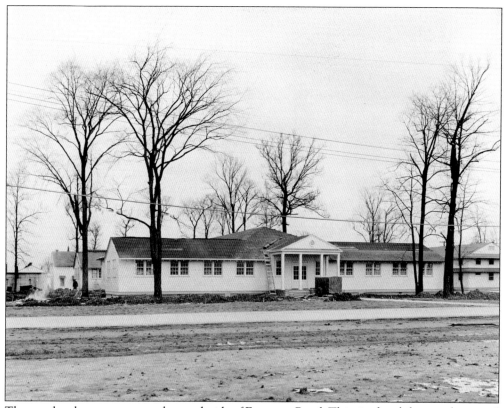

The post headquarters was on the north side of Ferguson Road. This site faced the parade ground that was on the south side of Ferguson Road. The base headquarters temporarily housed the offices of the Women's Army Corps (WAC) commander in 1944. After the war, this building became the home of the Fort Wayne Ground Schools. (Courtesy of CWO Harry Smith.)

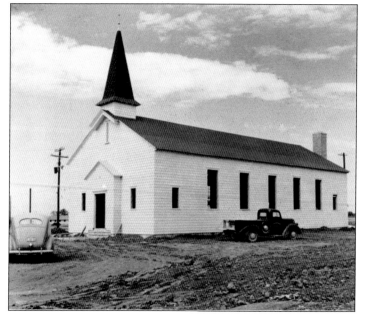

The base chapel was the site of many weddings and services for all faiths during World War II. The principal chaplain was Rev. Herman H. Backs, who was simultaneously a pastor at a Lutheran church in Waynedale, Indiana, which was four miles north of the base. After the war, St. Theresa Catholic Church purchased the building and moved it to Waynedale, Indiana. (Courtesy of CWO Harry Smith.)

Garrick Construction Company built many of these standard two-story barracks at Baer Field. The barracks housed 62 men and included toilet and shower facilities. The beds were standard-issue bunk beds. Each level had one private room for the barracks sergeants. The rotating beacon tower is barely visible in the distance on the right side of this photograph. (Courtesy of Garrick Construction Company.)

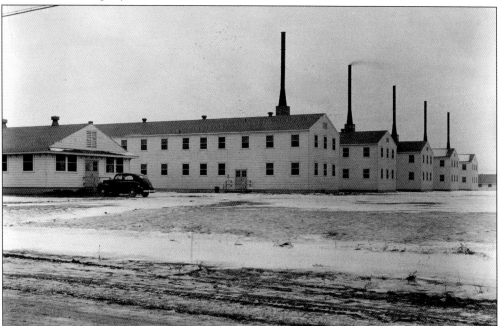

Garrick Construction Company completed the Bachelor Officer Quarters (BOQ) shown in this photograph in 1942. The BOQ provided private rooms for officers at the base for temporary duty. Coal furnaces provided heat in the individual rooms. The officers' mess is in the left foreground and was often open 24 hours a day. (Courtesy of the US Army Corps Engineers.)

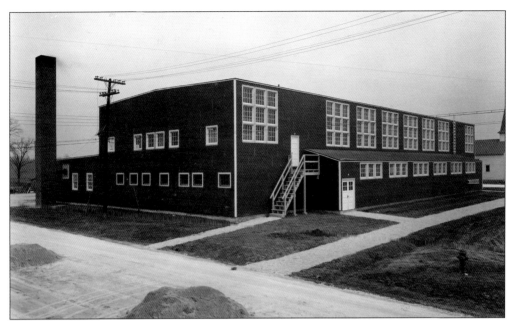

The Thorp-Rogoff Company of Fort Wayne completed the recreation building in 1943. This building contained a fully equipped gymnasium, and many sporting events took place there. The facility was open for use 24 hours a day. Cpl. Hilliard Gates, who later became the general manager and sports announcer for WKJG-TV, was sports coordinator for the base. (Courtesy of Fort Wayne International Airport.)

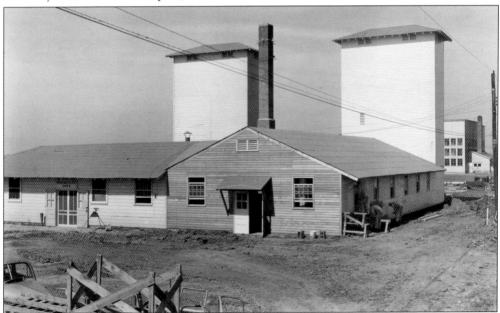

Hagerman Construction Company completed these parachute inspection towers in 1943. When preparing for a flight, each airman would requisition a parachute for himself. Trained personnel would remind him of the procedures for activating the chute and how to care for it when it was not being worn. The tall structures permitted the chutes to be periodically unpacked and inspected thoroughly. (Courtesy of CWO Harry Smith.)

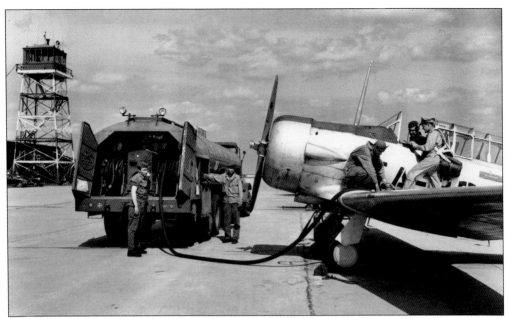

This photograph shows an AT-6 Texan trainer aircraft being fueled on May 1, 1947. The military control tower is visible on the left side of the photograph. By this point, fire had destroyed the main hangar that stood next to the tower. The area pictured here would soon be the location of the Baer Field passenger terminal on the west ramp of the airport. (Courtesy of Indiana Air National Guard.)

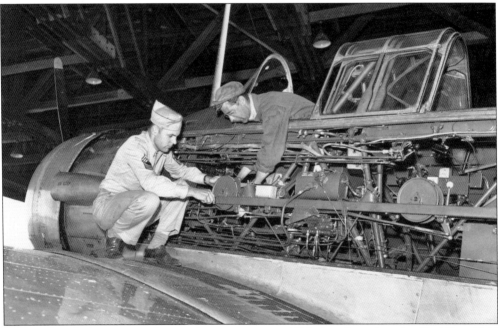

Two unidentified airmen perform maintenance on an AT-6 aircraft stationed at Paul Baer Field shortly after the end of World War II. Former World War II–pilot Lt. Paul H. Randall and the author, who was a former World War II bombardier, checked out an AT-6 several times in early 1948 from the active Army Air Corps reserve unit. (Courtesy of Baer Army Air Base files.)

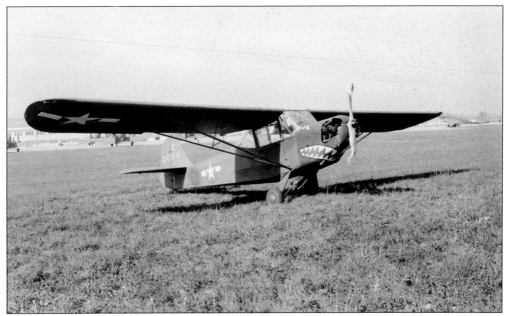

The Aeronca L-3 Grasshopper entered military service during Louisiana and Texas maneuvers conducted in August and September 1941. In those exercises, the Grasshopper was primarily a courier and light-transport aircraft. Partly because of its habit of stalling and entering a spin when making a left turn, its role was primarily as a US-based trainer. (Courtesy of Baer Army Air Base files.)

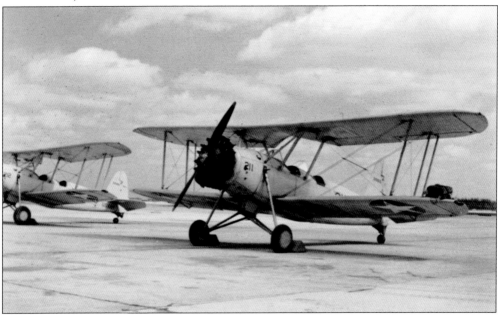

The Boeing-Stearman Model 75, also known widely as "Kaydet," was the primary training aircraft for pilots during World War II. While Stearman was formally a subsidiary of Boeing, the Stearman name stuck for this ubiquitous aircraft. The Kaydet in this photograph, taken in 1942, appears to be ready for a training mission, as a parachute is waiting on the left wing. (Courtesy of Paul Baer Air Base files.)

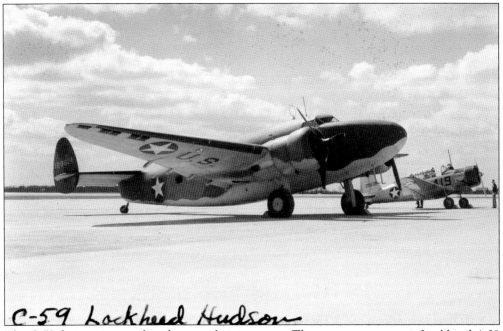

C-59 Lockheed Hudson

The C-59 designation on this photograph is incorrect. The proper taxonomy is Lockheed A-29 Hudson. The British used Hudsons as light bombers and coastal reconnaissance aircraft during the early stages of World War II. This specific aircraft was modified at Paul Baer Field for use as a gunnery trainer. (Courtesy of Baer Army Air Base files.)

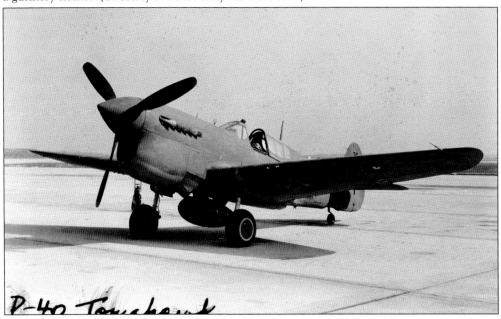

P-40 Tomahawk

A Curtiss P-40 Warhawk, also known as "Tomahawk," is pictured here on the ramp at Paul Baer Field with an additional belly-mounted fuel tank. Pilots dropped these extra fuel tanks when they became empty to improve air-to-air combat maneuverability. A fire bottle is visible above the right main gear. These fire bottles where kept on the flight line when starting aircraft engines to extinguish any fires that started. (Courtesy of CWO Harry Smith.)

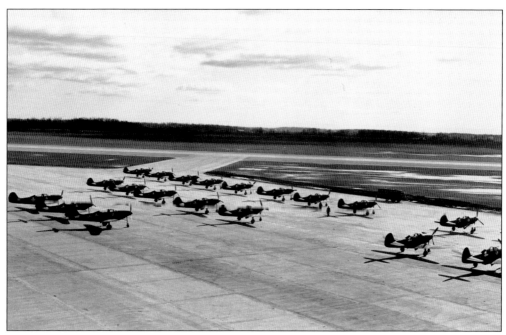

This photograph, taken looking southwest from the tower, shows many parked Bell P-39 Airacobra aircraft. This squadron of Airacobras passed through Baer Army Air Base on its way to the West Coast in late 1941. The aircraft was one of the first fighters stationed at the Baer Army Air Base. (Courtesy of Fort Wayne International Airport.)

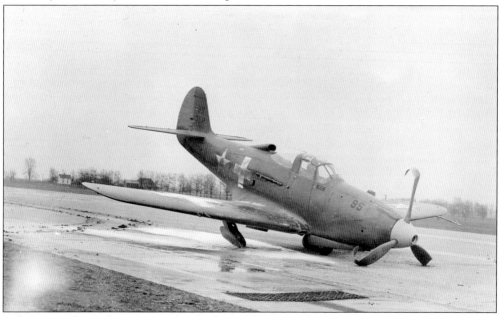

In late 1941, this Bell P-39 Airacobra had a problem while landing. This photograph shows two of the fighter's distinguishing features. The first feature is the 37-milimeter T9 cannon that fired through the propeller hub. The second feature is the engine that was mounted mid-ship, behind the cockpit. The Airacobra was the principal US fighter at the start of World War II. (Courtesy of Baer Army Air Base files.)

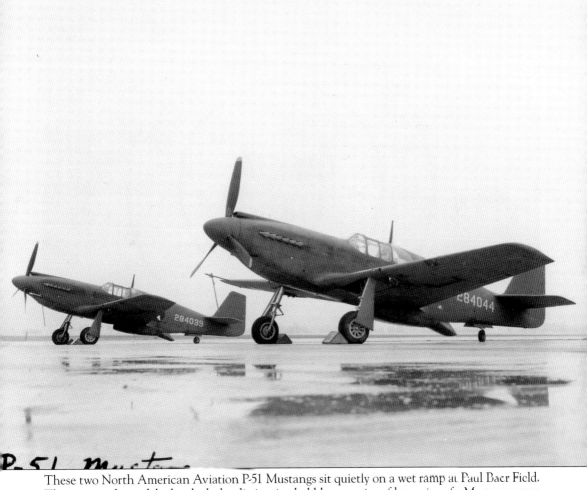

These two North American Aviation P-51 Mustangs sit quietly on a wet ramp at Paul Baer Field.
These are early models that lack the distinctive bubble canopies of later aircraft. Mustangs were
arguably the most famous and most effective allied fighter aircraft in World War II. The early
versions of the Mustang had the Allison V-1710 engine, which limited it to low-altitude operations.
The later P-51D version used the more powerful Packard V-1650-7 Merlin engine, a version of the
Rolls-Royce Merlin 60 engine series. With the new engine and its sizeable internal fuel tanks,
the P-51D Mustang found its niche escorting Boeing B-17 Flying Fortress and Consolidated
B-24 Liberator aircraft on their long-range bombing missions over Europe. In fact, when using
150-octane fuel, Mustangs were fast enough to chase down V-1 rockets launched from Germany
toward London. (Courtesy of Baer Army Air Base files.)

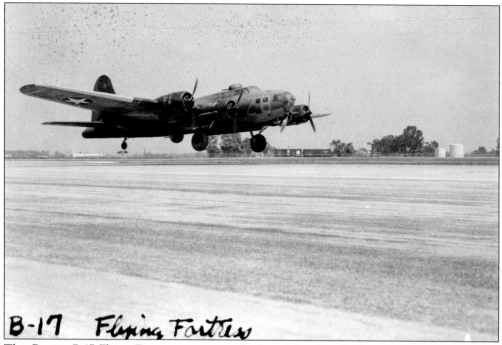

B-17 Flying Fortress

This Boeing B-17 Flying Fortress attempts a dead-stick landing (with no engines running) on Runway 22. B-17s served primarily as high-altitude, precision daylight bombers against German military and industrial targets. B-17s earned the reputation of being able to fight their way to and from their target and return home despite significant battle damage. Among all US aircraft, B-17s dropped about 40 percent of the bombs in Germany. (Courtesy of Baer Army Air Base files.)

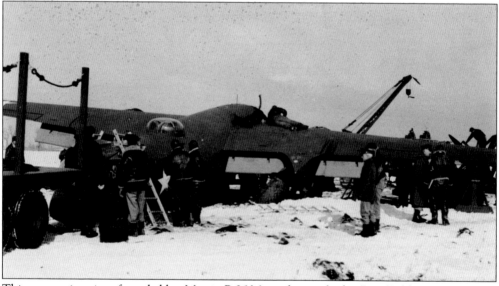

This two-engine aircraft, probably a Martin B-26 Marauder, crashed at Baer Field in January 1943. The left engine is already propellerless. The right engine appears to be present, and its propellers are partially visible above the wing on the right side of the photograph. The tail gunner's position is between the two men standing behind the truck on the left side of the photograph. (Courtesy of Fort Wayne International Airport.)

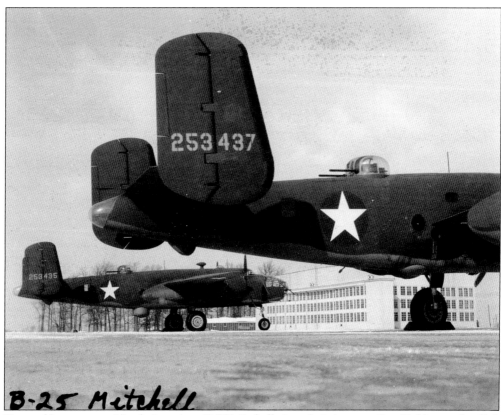

B-25 Mitchell

Pictured here are two North American B-25 Mitchell aircraft sitting on a Baer Field ramp. Lt. Col. James "Jimmy" Harold Doolittle used this type of medium bomber during the first US aerial raid on mainland Japan during World War II. On April 18, 1942, Doolittle led a bombing mission composed of 16 B-25s that took off from the deck of the aircraft carrier USS *Hornet*. (Courtesy of CWO Harry Smith.)

This North American B-25 Mitchell crashed at Smith Field (formerly Paul Baer Municipal Airport), probably in 1943 while attempting a landing on Runway 13. The interurban railroad tracks run from the bottom left of this photograph. The control tower is barely visible over the tail of the aircraft. Apparently, all crew onboard survived the crash landing. This aircraft probably lost its right engine while flying north of Fort Wayne and opted to attempt landing at an alternate airport. (Courtesy of Fort Wayne International Airport.)

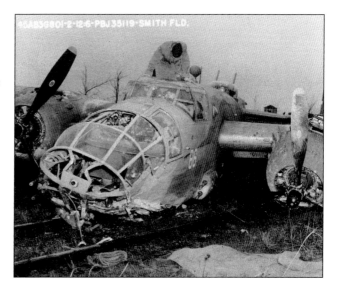

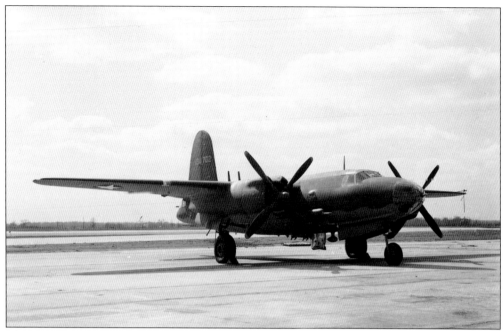

The Martin B-26 Marauder was a medium bomber that started World War II with the moniker of "Widowmaker" because it needed to take off and land at precise speeds. With the addition of longer wings and larger control surfaces, the B-26 ended the war with the lowest loss rate of any US Army Air Corps bomber. (Courtesy of Paul Baer Air Base files.)

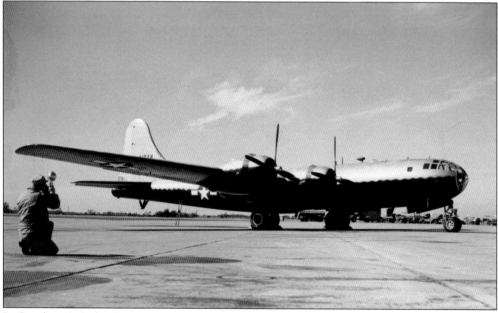

In October 1945, this Boeing B-29 Superfortress passed through Baer Field. Boeing developed the B-29 as a replacement for its Boeing B-17 Flying Fortress bomber; the goal was to create aircraft that were able to reach Japan from land-based airfields. B-29s were capable of reaching an altitude of 40,000 feet and 350 miles per hour, which put them virtually out of reach of any Japanese fighters. (Courtesy of Fort Wayne International Airport.)

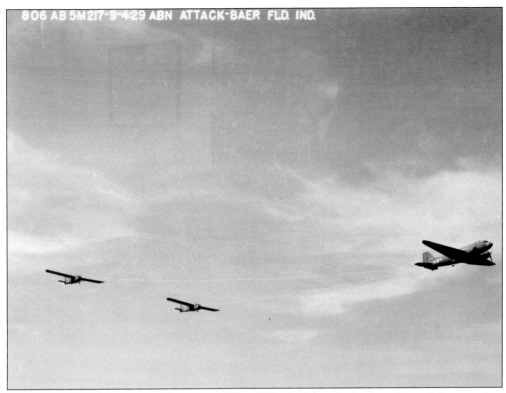

A Douglas C-47 Skytrain aircraft tows two Waco CG-4A gliders during invasion training exercises in early 1944. Waco CG-4As could carry 13 combat-equipped troops, a small artillery piece, or a jeep with a crew of two. The aircraft were part of the invasion of Sicily and the D-Day invasion of the European mainland. (Courtesy of Paul Baer Field files.)

In April 1945, this Curtiss-Wright C-46 Commando aircraft practiced discharging paratroopers while flying over Baer Field. A Waco CG-4A glider is in the lower left foreground of the photograph. This glider has a set of ramps that were used to load and unload vehicles or heavy equipment. (Courtesy of CWO Harry Smith.)

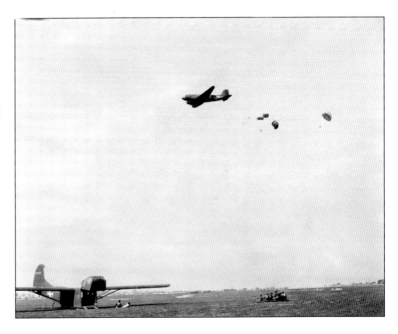

63

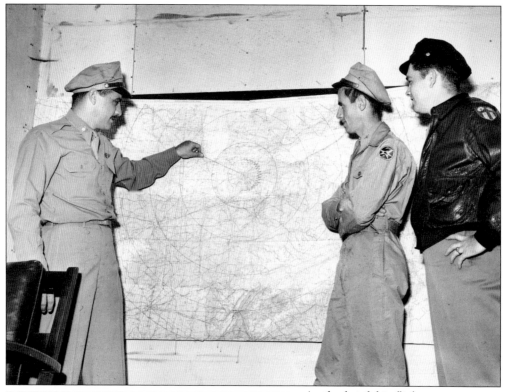

A pilot briefs his flight crew on their upcoming training mission in late 1944. The major, on the left wearing a summer uniform, is plotting a flight to the vicinity of Chicago. The officer in the center is wearing coveralls. The officer on the right is wearing one of the famous bomber jackets that appears to sport a Flying Tiger patch, indicating service in Burma. (Courtesy of CWO Harry Smith.)

Maj. J.A. Booth gives Capt. Clarence Cornish an eye examination in 1942. Cornish, who served in World War I, returned to service during World War II and reached the rank of colonel, serving in the Pentagon. He later became the first aeronautical commissioner in Indiana. (Courtesy of CWO Harry Smith.)

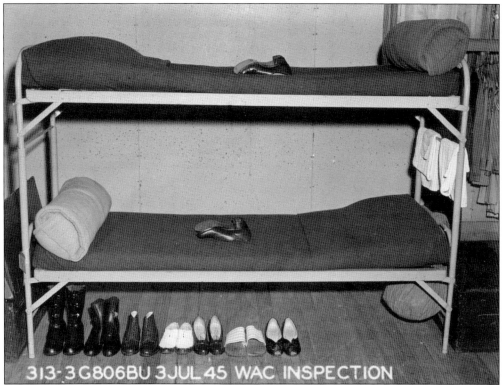

313-3 G806BU 3 JUL 45 WAC INSPECTION

This photograph, taken on July 3, 1945, shows the double bunks in the Women's Army Corps (WAC) barracks ready for inspection. On each bed sits a bedroll and one pair of shoes. Shown on the floor are seven additional pairs of footwear. At the head of the bottom bunks hang two sets of towels, presumably one set for each of the women. (Courtesy of CWO Harry Smith.)

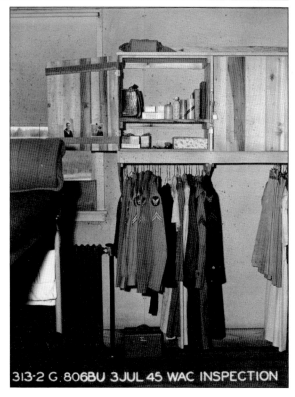

313-2 G.806BU 3JUL 45 WAC INSPECTION

This photograph, taken on July 3, 1945, shows the carefully positioned uniforms that belonged to one or two WAC members inside the barracks and ready for inspection. Above the hanging clothes is a storage area for personal effects. Some of the personal effects shown in this photograph include a hairbrush and a box of facial tissues. (Courtesy of CWO Harry Smith.)

65

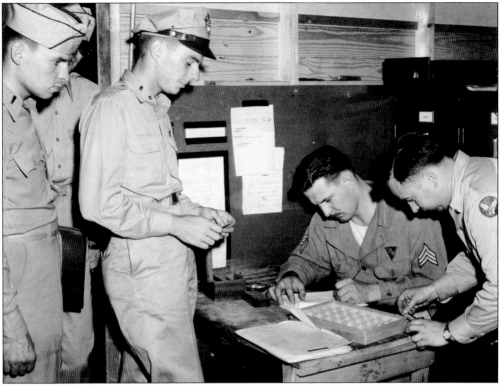

This photograph shows a group of new pilots reporting to be in-processed for new identification credentials. Depicted in this photograph is a company clerk, seated at the desk and supervised by his first sergeant (right). The first sergeant appears to be constructing identification nameplates for use in the soon-to-be-taken photographs. (Courtesy of CWO Harry Smith.)

This photograph shows the Jeep assigned to the officer of the day near the base chapel. Sitting on the left is the late CWO Harry Smith, who was the officer of the day in this photograph. The chapel (see page 52) was one of the first buildings constructed. (Courtesy of CWO Harry Smith.)

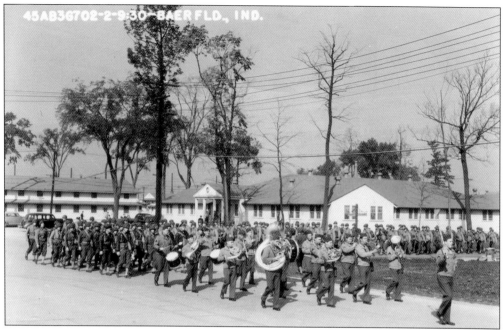

The Baer Field Band marches on Ferguson Road, passing the headquarters building on their way to the parade ground. In the background, a group of soldiers follows the band. The band members appear to be wearing their Class-B uniforms with service caps. The non-band personnel are wearing combat helmets (steel pots), load bearing equipment (LBE), and leggings. (Courtesy of Paul Baer Field files.)

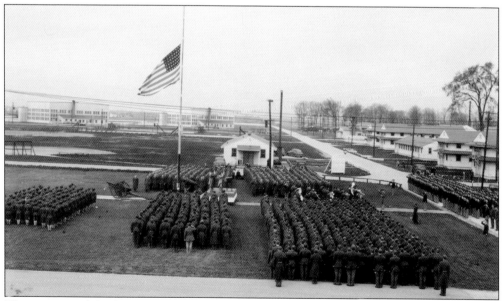

The unexpected death of President Roosevelt led to this base retreat on April 15, 1945. Notice that the American flag flies at half-staff. This ceremony, like many throughout the nation and world, honored the death of the commander-in-chief. The officers stand in formation along Ferguson Road. The ceremonial cannon faces to the south near the flagpole. (Courtesy of CWO Harry Smith.)

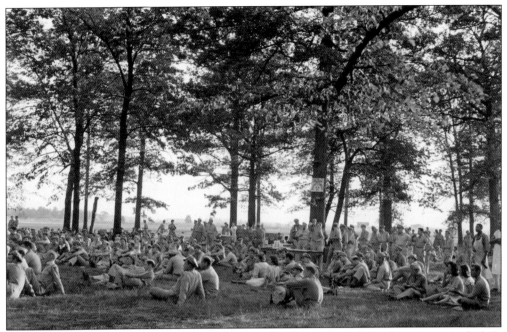

This photograph depicts a large group of soldiers with a few cooks and females interspersed while relaxing in the wooded area of the northwest corner at Baer Army Air Base. This photograph was taken on August 10, 1945, the day after the second atomic bomb destroyed Nagasaki, Japan. Japan would formally surrender on August 15, 1945. (Courtesy of Baer Army Air Base files.)

On August 10, 1945, base activity ceased for most of the day when President Truman announced that Emperor Hirohito of Japan had ordered his troops to accept the terms of surrender. Upon hearing of the surrender, Baer Field soldiers relaxed and contemplated the future. This photograph is a different view of the same gathering that appears in the above image on this page. (Courtesy of Baer Army Air Base files.)

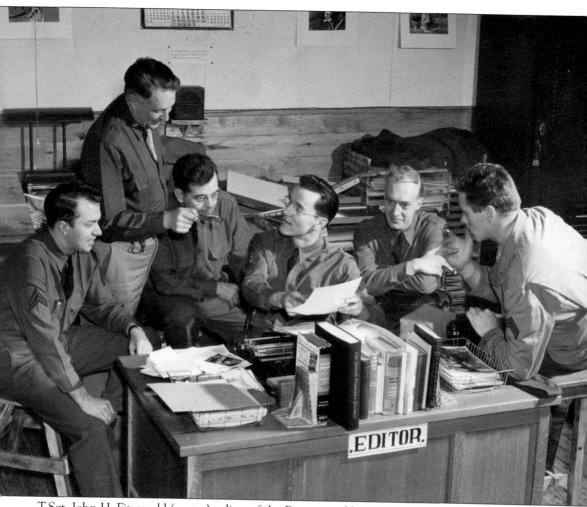

T.Sgt. John H. Fitzgerald (center), editor of the *Beacon*, and briefs his assistants while preparing for an upcoming edition. Fitzgerald and his small staff edited and printed the *Beacon*, which was distributed every Friday to the base personnel. A typical edition included a schedule of USO shows and other entertainment, chapel services, and training events. Interviews with soldiers having special talents were popular. Budding cartoonists developed their skills. The *Beacon* often published accounts of local sporting events, both on and off base. Commanders often included a "message to the troops." The *Beacon* also covered engagement, wedding, and birth announcements. However, the most popular by far were the scuttlebutt articles. Fitzgerald would later attend Officers Candidate School and receive a commission as an officer. Following World War II, Fitzgerald made his home in Fort Wayne. (Courtesy of CWO Harry Smith.)

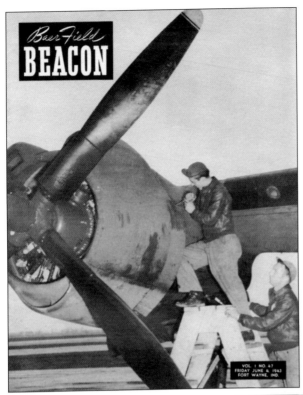

The *Beacon* was the weekly publication of the public relations office at Baer Field and Troop Carrier Command at Fort Wayne, Indiana. This image shows an edition distributed on June 4, 1943, and portrays two unidentified aircraft mechanics working on what is probably a Martin B-26 Marauder. (Courtesy of Greater Fort Wayne Aviation Museum.)

This edition of the *Beacon* was published on September 15, 1942, and shows three soldiers training in anti-aircraft operations. Note how they are wearing World War I–style helmets. The gun is probably a M1917 Browning 0.30-caliber machine gun. The gun used water-cooling to allow sustained high rates of fire. (Courtesy of Greater Fort Wayne Aviation Museum.)

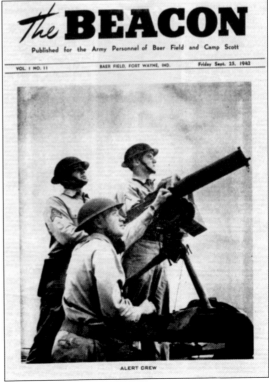

This building had housed the Red Cross facility during the war. After the war, this building quickly converted to civilian housing to ease the acute shortage of available homes. The Jim Perry family of Fort Wayne made their home in this building, and their children certainly had plenty of room for outdoor activities. (Courtesy of the Jim Perry family.)

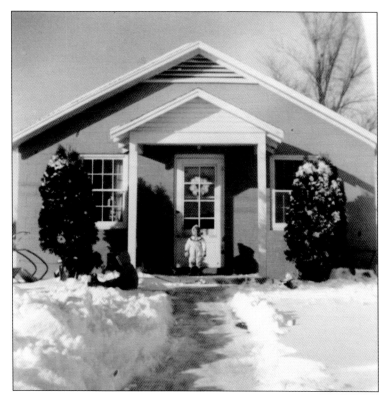

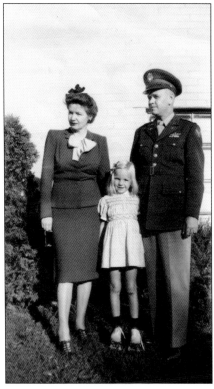

Col. Clarence Cornish, his wife, Lois, and their daughter, Ruth, depart for a social event in this c. 1944 photograph. Colonel Cornish was an aviator in World War I and served during World War II. One of his duties during World War II was to convince the US Army Air Corps and US Naval Aviation to cooperate and coordinate their use of airspace for towed target practice along the Florida coast. (Courtesy of Clarence Cornish family.)

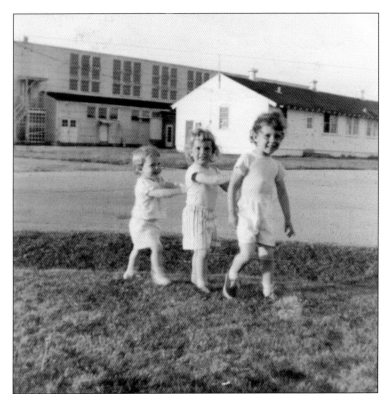

From left to right, Jeanne, Judy, and Joan Perry play in the yard of their post–World War II temporary housing for veterans at Baer Field. The World War II recreation facility and an administration building are in the background. The Perry family occupied a remodeled Red Cross facility on the base. Several other families occupied World War II buildings, including the airport manager. (Courtesy of the Jim Perry family.)

Jan Perry, the mother of Jeanne, Judy, and Joan, poses in an abandoned foundation near the fire station in the 1950s. Many of the abandoned foundations when they were filled with water served as convenient wading pools. In winter, they made dandy but small ice-skating rinks. (Courtesy of the Jim Perry family.)

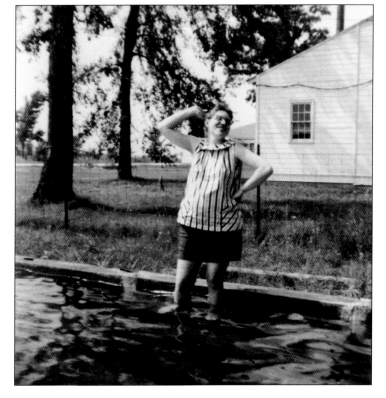

Three

RESERVATIONS REQUIRED

At the end of World War II, Transcontinental & Western Air (T&WA) shifted its operations from Smith Field north of Fort Wayne to Paul Baer Field on the southwest side of the city. The initial air passenger terminal was a small cinder-block building located on the west side of the field and was shared by T&WA and Chicago and Southern Air Lines (C&S). T&WA provided east-west service via Chicago, Illinois, and Columbus, Ohio. C&S flights ran north to Toledo, Ohio, and Detroit, Michigan, as well as south to Indianapolis, Indiana, and ultimately Memphis, Tennessee. United Airlines initiated service to Fort Wayne around 1950 with service to Chicago, Illinois, and Cleveland, Ohio.

In 1951, a new passenger terminal was built on the north side of the airport. That terminal building included the Outlook restaurant and a coffee shop. The Outlook restaurant offered a clear view of the passenger aircraft operations and was a popular dining location for local residents for many years. The terminal building included an outdoor observation deck and a new air traffic control tower that replaced the tower that had been inherited from the US Army Air Corps.

After many expansions and modifications, the current passenger terminal remains situated on the same site. The current terminal has four jet bridges, a sports bar, a gift shop, several car rental agencies, and ticket counters for Delta Air Lines (successor to C&S), American Eagle Airlines, United Express, and Allegiant Air. At various times, Fort Wayne was the corporate headquarters for Hub Airlines and was the primary maintenance base for Air Wisconsin. However, Fort Wayne International Airport's most exceptional feature is the welcome counter that faces the exit from the TSA security screening area. Every incoming passenger is offered a fresh seasonal cookie.

While Fort Wayne has never had large numbers of boarded passengers, it has often seen significant airfreight loads. During the late 1960s, United Airlines operated a daily Douglas DC-8 freighter to Chicago. During the 1970s, Delta Air Lines's Fort Wayne operation often placed in the top 10 for airfreight in spite of only having six daily Convair CV-440 departures.

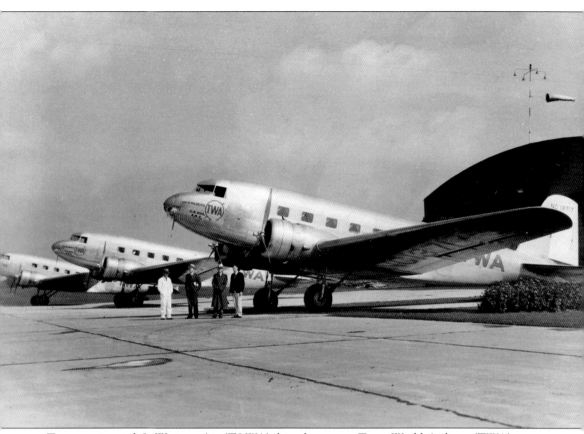

Transcontinental & Western Air (T&WA), later known as Trans World Airlines (TWA), was one of the Big Four airlines in the late 1930s that provided the United States with coast-to-coast service. United Airlines provided service from the East Coast to West Coast through Chicago. American Airlines provided similar service through Dallas. T&WA provided coast-to-coast service through St. Louis. Eastern Air Lines primarily provided north-south service along the eastern seaboard. The three T&WA Douglas DC-2 aircraft in this photograph are sitting in front of Hangar Two at Paul Baer Municipal Airport (now Smith Field). These aircraft were most likely on their way to either Chicago Midway Airport or Port Columbus International Airport in Columbus, Ohio. Having three aircraft on the ground simultaneously was a special event and probably was the impetus for this photograph. The DC-2 aircraft were not pressurized and normally carried about 21 passengers primarily in daytime service. American Airlines purchased TWA in 2001. (Courtesy of Smith Field files.)

This is the original commercial and passenger terminal on the west side of Baer Field that opened in 1945. The Army Air Corps still operated on the north and east sides of the field. Trans World Airlines and Chicago and Southern Air Lines were the first tenants. The building ceased operation in 1953, when the new passenger terminal on the north side of the field opened. (Courtesy of Roger Myers.)

A group of passengers and observers waits for an aircraft arrival on the ramp side of the original Baer Field passenger terminal in this c. 1949 photograph. A Chicago and Southern Air Lines captain stands in the doorway on the right of the picture. Although the United Airlines shield is visible, only Chicago and Southern Airline and TWA physically occupied this terminal. (Courtesy of Roger Myers.)

The original passenger terminal on the west side of Baer Field opened while World War II was still very much in progress in early 1945. The building was in an area secluded from any military activity. This winter scene shows the airport side of the cement-block structure that housed TWA, United Airlines, and Chicago and Southern Air Lines. Chicago and Southern Air Lines handled United Airlines's ground operations. (Courtesy of Roger Myers.)

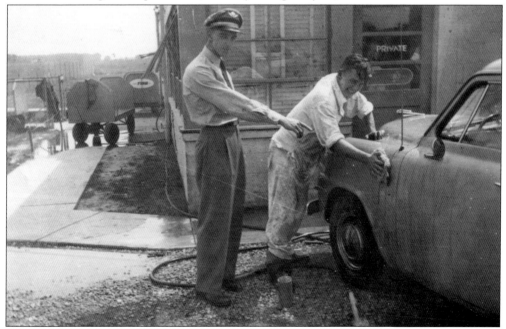

John Willig (left) and William "Bill" Gardner, Chicago and Southern Air Lines agents, utilize some slack time by washing their individual automobiles near the passenger terminal on the west side of the airport. In the late 1940s, the agents had considerable time between flights and used some of this time for personal chores. (Courtesy of Roger Myers.)

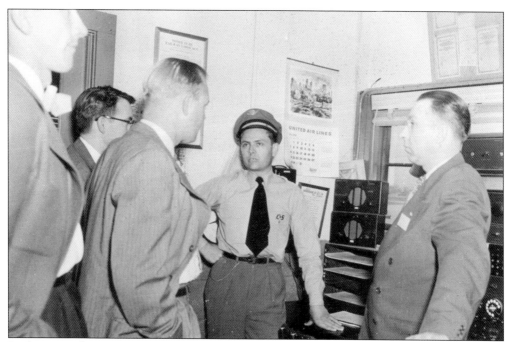

In the original terminal, which was on the west side of the field, Dan Baker, who was a Chicago and Southern Air Lines station manager, describes operations to a group of executive visitors. Shown on top of the desk are two speakers. One speaker broadcast audio from Baer Field's control tower, while the other broadcast audio from Chicago Midway's control center. (Courtesy of Charles Gresham.)

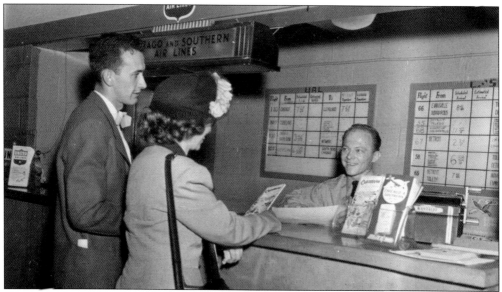

Chicago and Southern Air Lines (C&S) ticket agent Charles Gresham processes two passengers in the original Paul Baer Field terminal. This cinder-block building had been recently constructed on the west side of the airport. The schedule on the left is for United Airlines, and the one on the right is for C&S. The building offered the usual amenities of restrooms, public telephones, and vending machines. (Courtesy of Roger Myers.)

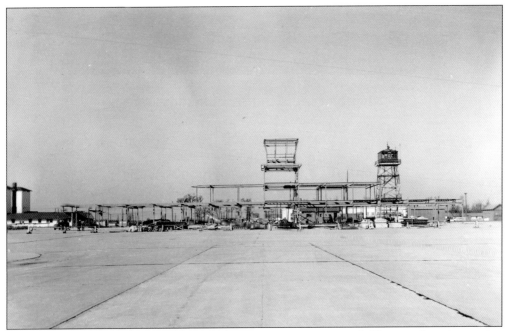

In the early 1950s, construction began on the new passenger terminal. The parachute inspection towers, visible to the left, remained for several more years beyond this 1952 photograph. The World War II tower was still in service, and none of the debris from the 1946 fire that destroyed the main hangar remains. (Courtesy of Roger Myers.)

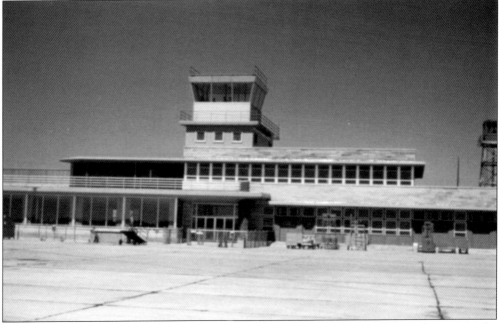

Taken around 1953, this north facing view shows the not-yet-completed control tower in the middle of the photograph. The older control tower was constructed for the Army Air Corps in 1942 and was still in use. The airlines were in the process of relocating from the original passenger terminal on the west ramp. (Courtesy of Roger Myers.)

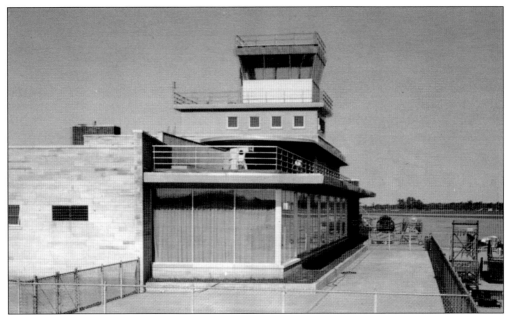

This photograph shows the new terminal that opened in 1953. This east-looking view shows the control tower before it became operational. The fence on the right side of the photograph contained several of the ground-level gates. The Look-Out Dining Room, which was popular with both travelers and the local community, operated behind the glass windows. The fenced area above the Lookout Restaurant was the observation deck. (Courtesy of Fort Wayne International Airport.)

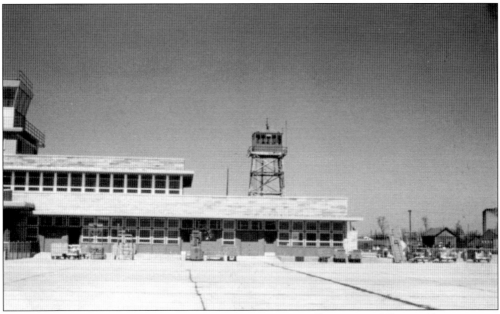

In 1953, the original control tower from World War II was still in service following the migration of the commercial airlines from the west ramp area to the north ramp. Although now officially part of Delta–C&S Air Lines, the ramp equipment still bears the colors of Chicago and Southern Air Lines. The chimney to the far right of the photograph poured out considerable black smoke during those early years. (Courtesy of Roger Myers.)

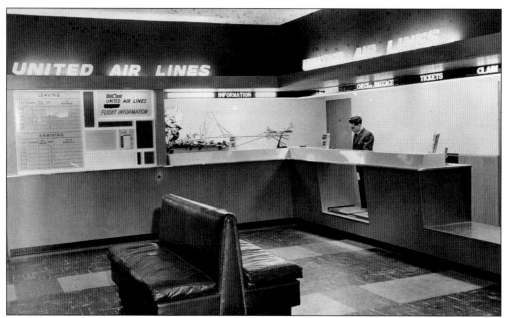

In early 1955, a United Airlines ticket agent awaits the next customer in the new passenger terminal building at Baer Field. The terminal at that time, served the needs of three airlines—United Airlines, Trans World Airlines, and Delta–C&S Air Lines. The lobby was modern in every respect and was one of the most efficient airline terminals in the United States. (Courtesy of Fort Wayne International Airport.)

Gale Myers operated the Look-Out Dining Room in the southwest corner of the new passenger terminal at Baer Field. It offered a clear view of the tarmac where Trans World Airlines, Delta Air Lines, and United Airlines conducted their ground operations. During the mid- to late 1950s, local residents looking for good food in an entertaining location often visited the Look-Out Dining Room for Sunday brunches and dinners. (Courtesy of Roger Myers.)

The Look-Out Dining Room is at the far end of the terminal. The Delta–C&S Air Lines ticket counter is on the left of the photograph. The Trans World Airlines ticket counter is also visible on the left but farther down the concourse. Every seating area had an ashtray available. (Courtesy of Fort Wayne International Airport.)

The United (left), Delta–C&S (center), and TWA (right) ticket counters are waiting for customers in early 1955. A US post office drop box is just visible on the left edge of the photograph. The black cylindrical objects near the seats are ashtrays. The Mutual of Omaha travel insurance machine is between the Delta–C&S and TWA ticket counters. (Courtesy of Fort Wayne International Airport.)

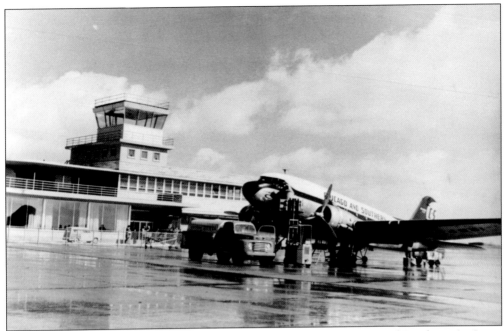

Ramp agents service, load, and fuel this Douglas DC-3 owned by Chicago and Southern Air Lines at Paul Baer Field. With a capacity of 21 passengers and full main fuel tanks, DC-3s had limited capacity for baggage and mail. Known as the workhorse of the airlines, some DC-3s are still flying on scheduled routes in the world. (Courtesy of Fort Wayne International Airport.)

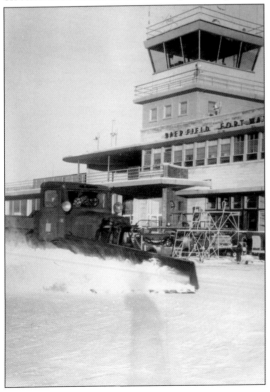

Airport employee Stan Winn drives a snowplow on the ramp side of the new Paul Baer Field terminal in the mid-1950s. The snow depth seems to approach one foot. The dedicated staff of airport employees, although few in numbers, kept the ramp and passenger areas safe and did double duty in the summer by mowing the several hundred acres. (Courtesy of Roger Myers.)

Torrance A. Richardson began his service as executive director of airports for the Fort Wayne–Allen County Airport Authority in early 2004 after working as the airport executive director of the Rapid City Regional Airport and as the airport operations officer at the Dubuque Regional Airport. He holds a bachelor of science degree in aviation management from the University of Dubuque. (Courtesy of Greater Fort Wayne Aviation Museum.)

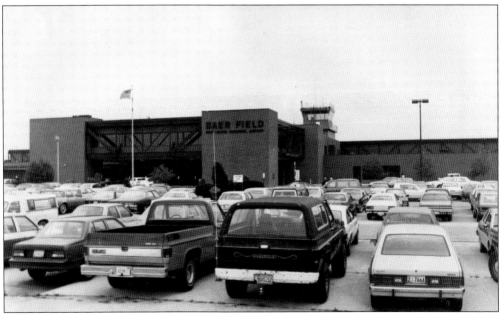

The newly remodeled Baer Field terminal building of the 1980s featured a covered passenger loading and unloading area and an enlarged baggage claim facility. This photograph shows the original air traffic control tower above the passenger terminal. The glassed-in area of the upper level, which is visible in this photograph, housed the Fort Wayne International Airport administrative offices. (Courtesy of Roger Myers.)

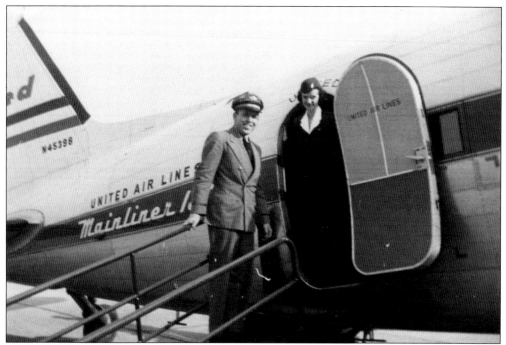

Roger Myers confirms his passenger list with a flight attendant prior to departure of this Douglas DC-3 owned by United Airlines at Baer Field in 1950. The DC-3 had a capacity of 21 passengers and a crew of one stewardess and two pilots. A few DC-3 aircraft remain in service. The DC-3 aircraft was not pressurized and had an outstanding safety record. (Courtesy of Roger Myers.)

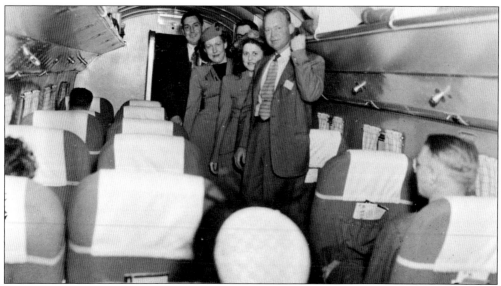

Passengers are boarding a Douglas DC-3 owned by TWA in this photograph, taken around 1950. The single restroom near the cockpit door accommodated both genders. The single stewardess could collect tickets, provide pillows, serve meals (one at a time), and collect used china during the 35-minute flight between Fort Wayne and Dayton. The fare during those years was $6.45 for a one-way ticket to Chicago, which included taxes. (Courtesy of Roger Myers.)

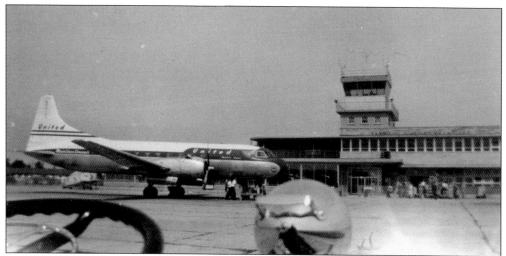

United Airlines served Fort Wayne with Convair CV-440 aircraft in the 1950s. The CV-440 brought a pressurized cabin for the safety and comfort of the passengers and served medium- to short-range routes throughout the United States. The cargo bins had ample space for baggage and cargo. (Courtesy of Fort Wayne International Airport.)

The Transportation Committee of the Fort Wayne Chamber of Commerce chartered this Douglas DC-6 owned by United Airlines to visit the modern air cargo facility that United had opened at O'Hare International Airport in Chicago. This charter included 60 area and local businesspeople, and the visit lasted from 11:00 p.m. to 3:00 a.m. (Courtesy of United Airlines.)

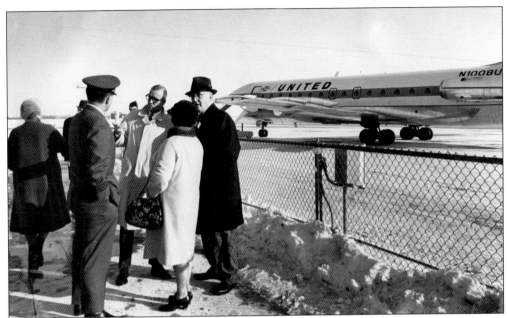

In February 1967, United Airlines initiated jet-powered service with Sud Aviation SE 210 Caravelle aircraft. Frank Hopper, a Fort Wayne native, was the captain for this inaugural service. In this photograph, James "Jim" Kerns, station manager for United Airlines, visits Captain Hopper's proud parents. This was the first scheduled jet service to Fort Wayne's Baer Field, and United Airlines was gracious in scheduling Hopper to make this historic first flight. (Courtesy of United Airlines.)

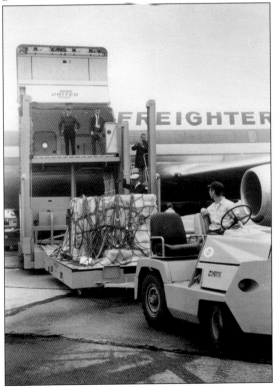

For several years around 1970, United Airlines operated a Douglas DC-8 freighter that served several eastbound and westbound markets. Pictured are several United Airlines personnel working a special lift that was capable of hoisting pallets of cargo. Some of the DC-8 cargo aircraft operated in dual service, handling both passengers and freight. (Courtesy of Robert Parker.)

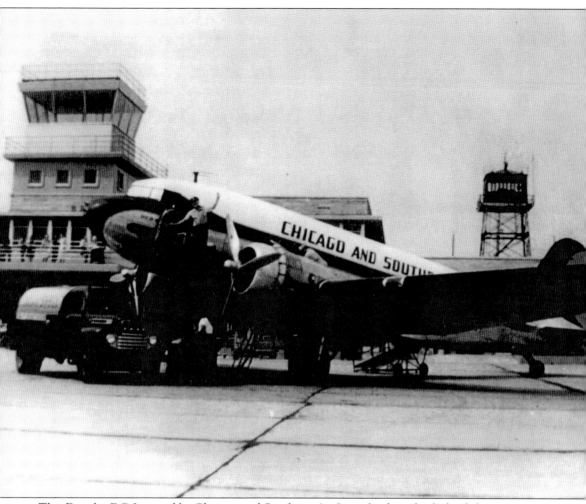

This Douglas DC-3 owned by Chicago and Southern Air Lines loads and refuels while sitting in front of the recently completed passenger terminal at Baer Field. This DC-3 was passing through Baer Field en route from Detroit, Michigan, to Memphis, Tennessee, via Indianapolis, Indiana. The passenger loading ramp is visible below the fuselage on the right side of the aircraft. A ladder is used to access the front cargo bin. Visible in the background are the first and second control towers. The original control tower, visible in the background on the right side of the photograph, was the tower used on the air base during World War II, and it remained in service for several more months. The second control tower, visible above the passenger terminal, was not operational at the time of this photograph. The observation deck is visible just in front of the aircraft's nose. (Courtesy of Fort Wayne International Airport.)

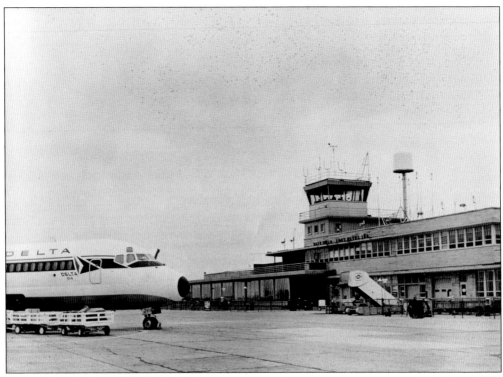

A Douglas DC-9 owned by Delta Air Lines arrives at the main passenger terminal in this c. 1970 photograph. A United Airlines passenger ramp is visible near the terminal. The marshmallow-looking object located behind the control tower is the weather radar device. United Airlines operated a mix of Douglas DC-6 and Boeing 737 aircraft through Fort Wayne during this period and the 1970s. (Courtesy of Roger Myers.)

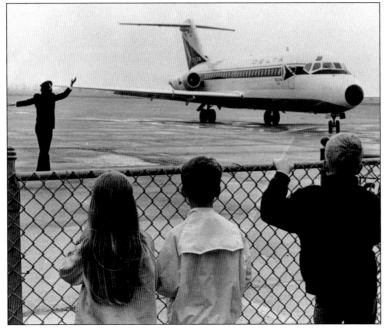

Delta's senior agent Robert Barnabee directs this Douglas DC-9 to the gate at Baer Field while several young children on a school tour observe his hand signals to the plane's captain. These hand signals instructed the aircraft captain on how he should move the aircraft to avoid any obstructions. Barnabee is wearing ear-protection devices. (Courtesy of Roger Myers.)

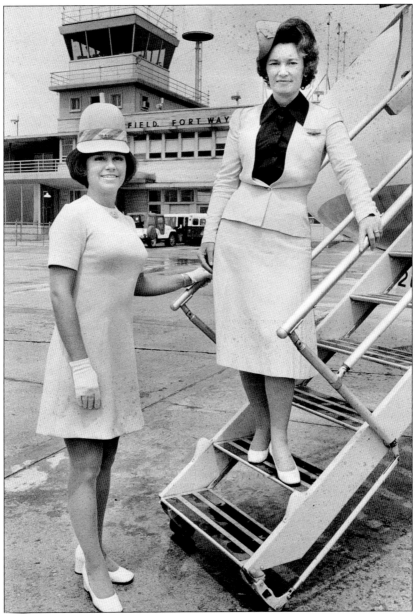

These Delta flight attendants display the new and the old uniforms while posing on the retractable steps of a Douglas DC-9 in front of the Baer Field terminal. Stewardesses, who are now called flight attendants, were the employees who had the longest contact with the passengers. The flight attendant on the stairs wears a uniform typical of the early 1940s, which was when they were required to be nurses and unmarried. This two-piece uniform seems more business like and is more modest. The flight attendant standing on the ramp is wearing a one-piece uniform typical around 1970. This short-sleeved uniform is a bit more stylish. The competition for these jobs was very fierce; the selection rate was about one candidate out of 20 applicants. Flight attendants underwent six weeks of training. About half of the training was on safety and emergency procedures. The other half of the training was on appearance, grooming, poise, and handling passengers. (Courtesy of *News-Sentinel*.)

This photograph shows the left side of one of the five Boeing Model 307B Stratoliners owned by TWA. This Stratoliner carried up to 33 passengers in relative luxury. Passengers could reserve swing-down berths for overnight travel. The Stratoliner had a top speed of 246 miles per hour with a cruising speed of 220 miles per hour and a range of 2,390 miles. (Courtesy of Trans World Airlines.)

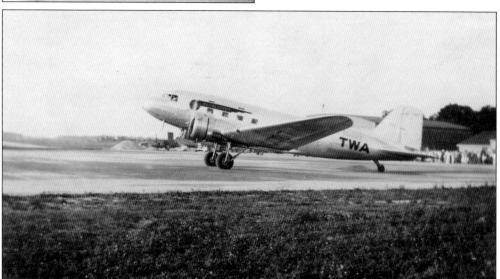

Several airlines commenced to serve Fort Wayne in the 1930s; Transcontinental & Western Airlines was among the first, using Douglas DC-2 aircraft for flights to and from Chicago Midway International Airport. The installation of ground facilities and runway lighting made Fort Wayne more viable for scheduled airline service. At about this time, the Board of Aviation Commissioners assumed responsibility for handling aviation affairs. (Courtesy of *News-Sentinel*.)

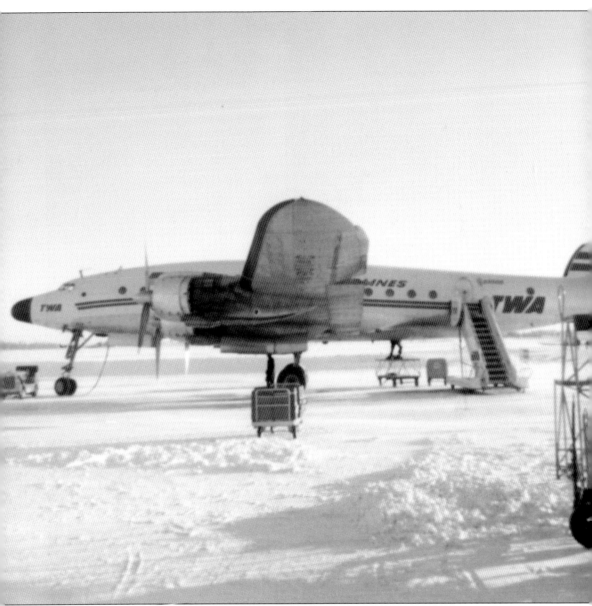

From 1930 to 1963, Trans World Airlines (TWA) served Fort Wayne with the Douglas DC-2 and DC-3 aircraft. For a number of years, TWA scheduled the Martin 4-0-4 aircraft to Fort Wayne before upgrading to luxurious Lockheed Constellation aircraft. This scene was typical of the Baer Field terminal ramp in the winter. The ground power unit, which is in front of the nose wheel, provided electrical power for interior lighting and radios while the engines where not operating. The ramp agent under the Constellation uses a single-level platform to reach the cargo bin. There is also a two-level platform on the right of the photograph. The baggage cart in the center is human powered. The last day of TWA operation to Fort Wayne was in June 1963 and coincided with TWA's single-day record for passenger boarding at Baer Field. (Courtesy of Roger Myers.)

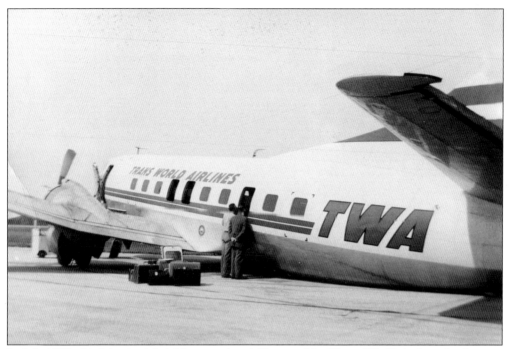

In July 1954, this Martin 4-0-4 (ship number 441) owned by Trans World Airlines had a gear failure during landing. The investigation determined that the pilot had raised the landing gear instead of the flap. Despite the damage to the aircraft, there were no personal injuries. TWA personnel removed the luggage by accessing the bin through the emergency exit. After repairs, this aircraft returned to service. (Courtesy of Roger Myers.)

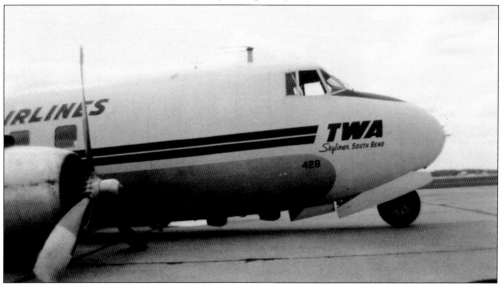

Almost one year after ship number 441's malfunction, Trans World Airlines experienced another landing gear failure on this Martin 4-0-4 (ship number 428) on the same runway as the picture above. TWA repaired the aircraft and placed it back into service. Pilot error was the official cause of this mishap. In spite of the considerable damage to the aircraft, there were no injuries. (Courtesy of Roger Myers.)

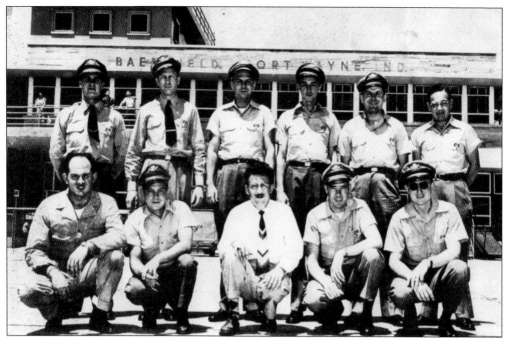

This 1951 photograph shows a group of Chicago and Southern Air Lines employees in front of the passenger terminal at Baer Field. Pictured in this shot are, from left to right, (first row) Frank Hopper, Rocky Fedeli, John Woods (sales manager), Bob Vetter, and William Hanes; (second row) Chuck Sabow, Lamar Doughty (station manager), Joe Murnane, John Willig, Roger Myers (author), and Arnold Helton. (Courtesy of Delta Air Lines.)

In 1952, Lamar Doughty, who was station manager of Chicago and Southern Air Lines (C&S), presents a Flying Colonel award to James "Jim" Ross, the Baer Field manager, while Helen Luker (C&S flight attendant) and John Woods (C&S marketing manager) extend their congratulations. The Flying Colonel award honored those individuals who contributed their time and talent freely toward the advancement of aviation. (Courtesy of Fort Wayne International Airport.)

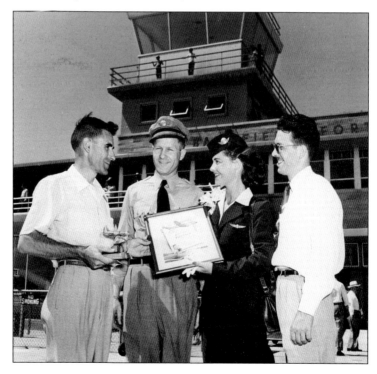

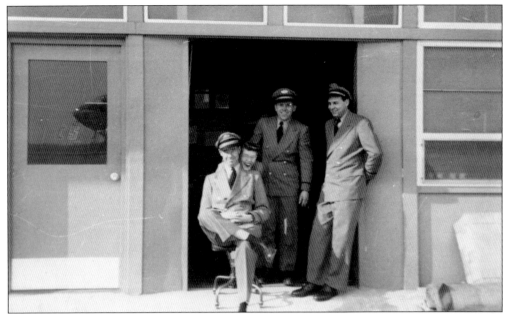

Robert "Bob" Vetter (left), "Taps" Hein (behind Vetter), Roger Myers (center), and Joseph "Joe" Murnane await the arrival of the next Chicago and Southern Air Lines flight. These four employees are wearing Chicago and Southern Air Lines uniforms. Although they are enjoying a bit of fresh air, they always stayed within earshot of the telephones and ticket counter bell. (Courtesy of Roger Myers.)

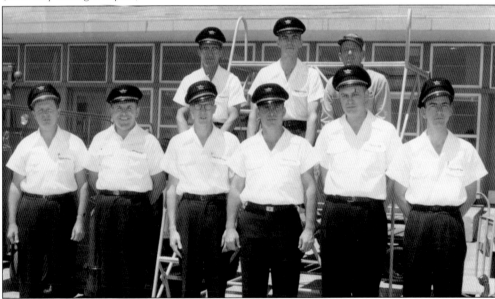

In this early 1959 photograph, Delta Air Lines' employees pose as a group at Baer Field. Pictured from left to right are (first row) Cleo Lord (station manager), Roger Myers, Dick Meredith, Frank Seaton, Roy Moodie, and Bill Walters; (second row) Chuck Sabow, Ray Leopard, and Ray Kneller (mechanic.) This picture reflects the merger of Delta Air Lines with Chicago and Southern Air Lines. The uniforms worn in this photograph are from Delta Air Lines. (Courtesy of Fort Wayne International Airport.)

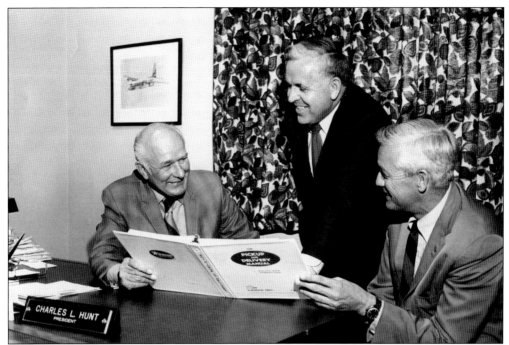

Charles "Chuck" Hunt (left), owner of Jet Air Freight & Parcel Delivery, Inc.; Roger Myers (author, center) from Delta Air Lines; and James Kerns from United Airlines meet for an airfreight conference. The coordination of aircraft ramp space and the placement of ramp equipment was a constant conversation between these three men. In spite of constrained airlift capacity, Fort Wayne businesses generated a large volume of air cargo. (Courtesy of Robert Parker.)

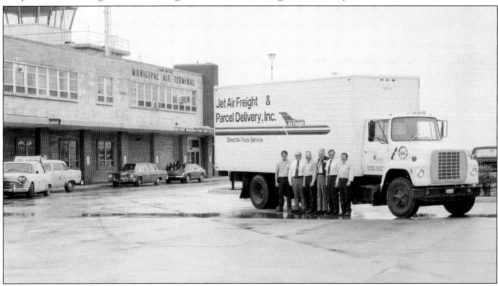

Jet Air Freight & Parcel Delivery, Inc., operated as an airfreight pickup and delivery service to northeast Indiana and northwest Ohio for many years. Charles "Chuck" Hunt, who started the business with the delivery of pharmaceutical prescriptions, owned Jet Air Freight & Parcel Delivery, Inc. It maintained a fleet of about 12 vehicles to accommodate the needs of the industries and shippers and constructed the first cargo facility at Baer Field. (Courtesy of Robert Parker.)

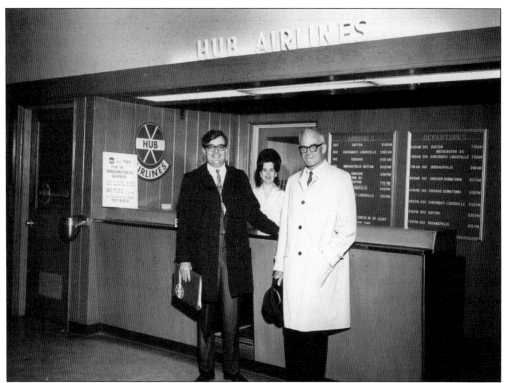

In this photograph, Dick Showalter (left), Trish Birkenbeul, and Sen. Berry Goldwater are standing in front of Hub Airlines' ticket counter. Hub Airlines provided service to several Midwest cities from Baer Field. George Bailey, who was well known in aviation circles in Fort Wayne, financed the purchase of Beechcraft aircraft to start Hub Airlines. Hub Airlines charged fares that were very competitive with the major airlines. (Courtesy of Hub Airlines.)

The Honorable Winfield "Win" Moses (right), mayor of the City of Fort Wayne, proclaims Delta Air Lines Day in 1980, celebrating 35 years of airline service to this city with Roger Myers. Mayor Moses continued to recognize the airlines with special proclamations, highlighting the growth and importance of the major airlines serving the Fort Wayne market. (Courtesy of the City of Fort Wayne.)

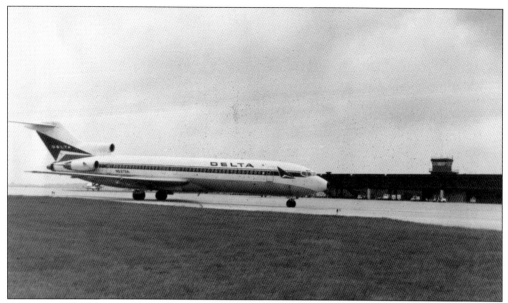

A Boeing 727-200 owned by Delta Air Lines approaches the passenger terminal at Paul Baer Field in the 1980s. Delta Air Lines' flight equipment previously included Douglas DC-3 and Convair CV-440 aircraft. Delta Air Lines started flying Boeing 727-200 aircraft into Fort Wayne in June 1974. For several years, Delta's fleet included more Boeing 727s than any other airline. Fort Wayne industries generated considerable air cargo that these larger aircraft more easily accommodated. (Courtesy of Max Gray.)

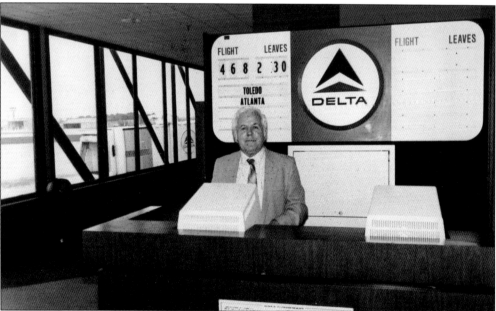

By June 1985, Delta Air Lines's station manager, Roger Myers, became the longest-employed person at Paul Baer Field. Here, Myers stands at the newly constructed second level at the check-in position. Myers went on another four years and retired in 1990, having completed almost 44 years of service with Delta Air Lines. One of new jet ways is visible through the windows on the left. (Courtesy of Delta Air Lines.)

Air Wisconsin, headquartered in Appleton, Wisconsin, served between Fort Wayne and Chicago O'Hare International Airport. For several years, Baer Field was Air Wisconsin's primary maintenance base. This de Havilland Canada DHC-7 Dash 7 aircraft seated about 40 passengers. The anti-tipping pole is visible below the tail of the aircraft and kept the aircraft stable during passenger and freight loading and unloading. (Courtesy of Roger Myers.)

Air Wisconsin placed its primary maintenance facility in this new hangar near the west ramp at Baer Field. Several other air carriers have occupied portions of this hangar for aircraft and ground equipment maintenance. This hangar continues to be an asset for aviation at this airport, particularly during the severe winter temperatures prevalent in northern Indiana. (Courtesy of Air Wisconsin.)

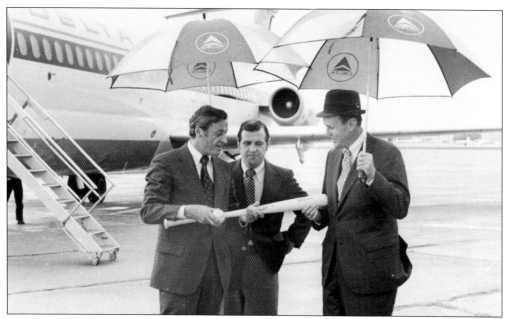

The baseball bat and ball used by Hank Aaron when he hit his 715th home run is accepted by Paul Shaffer (right), president of Fort Wayne National Bank, for safe keeping in the vault of Fort Wayne National Bank. Pictured from the left are Mark Bollman, Magnavox vice president of advertising and public relations; Don Hall, Magnavox sales promotion manager; and Shaffer. The ball and bat were temporarily in Fort Wayne around 1974 to support a public relations campaign for Magnavox, with whom Hank Aaron had a multimillion-dollar contract. (Courtesy of Fort Wayne International Airport.)

The Fort Wayne–Allen County Airport authority members break ground for additional parking to accommodate growing needs. The members of the board have the responsibility for the financial and operational needs of both Fort Wayne International Airport (formerly Paul Baer Field) and Smith Field. The board was led by director Lester Coffman, who is on the far right. (Courtesy of Fort Wayne International Airport.)

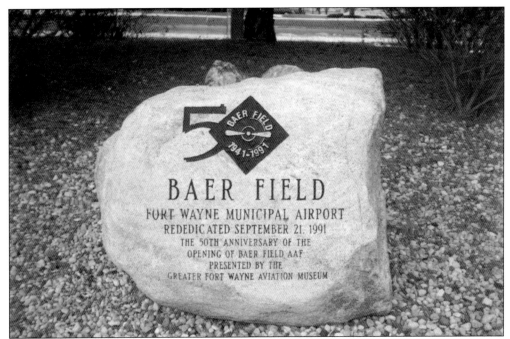

On September 21, 1991, Paul Baer Field celebrated the 50th anniversary of its opening as an army airfield in 1941. The US Army Air Corps originally proposed to expand the Paul Baer Municipal Airport, but the City of Fort Wayne counter-proposed a site on the southwest side of the city. The Greater Fort Wayne Aviation Museum donated this monument to commemorate the opening of Paul Baer Field. (Courtesy of Roger Myers.)

From left to right, Roger Myers (author), Clarence B. Cornish, Robert "Bob" Schott, and Roxanne Butler attended the dedication of the memorial stone commemorating the 50th anniversary of the activation of Paul Baer Field as a military base on September 21, 1941. Birkmeier & Sons Monument Company of Fort Wayne engraved the stone. (Courtesy of Roger Myers.)

Fort Wayne International Airport has been named "the Friendliest Airport in the United States" several times. This welcoming counter faces the exit from the Transportation Security Administration (TSA) screening area. These ladies and their peers are available to provide each person with driving directions, local information, and a warm smile. They also offer each arriving passenger a fresh, individually wrapped cookie. (Courtesy of Roger Myers.)

A Boeing 727-200 owned by Delta Air Lines approaches the ramp in this photograph, taken in approximately 1990. The Indiana Air National Guard's F-4 Phantom aircraft sit on the east apron in the upper portion of this photograph. Private general aviation aircraft are parked in the lower right corner of this image. (Courtesy of Fort Wayne International Airport.)

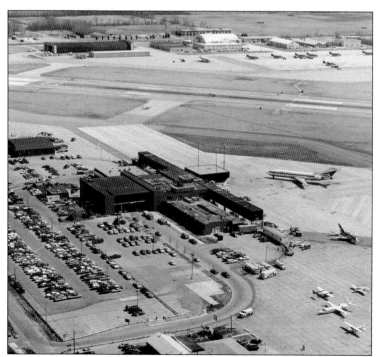

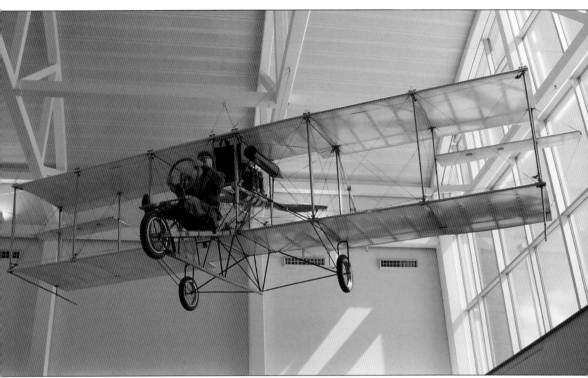

In 1997, this replica of the Arthur "Art" Smith aircraft hangs in the atrium of the Fort Wayne International Airport at the Paul Baer terminal. Art Smith's original aircraft can be seen in several photographs in chapter one. This aircraft incorporated several improvements over the Wright brothers' original design. The ailerons are visible as the small control surfaces are mounted between the wings near the wingtips. The pilot is in a sitting position, and the elevator is in the rear of the aircraft. The pilot's pockets contain several contemporary mementos placed by the team that suspended the aircraft. Robert "Bob" McComb (perhaps better known as "Uncle Fud" in his comical flyer persona at local air shows) led the team that built this replica, which once graced the Auburn Cord Duesenberg Museum, 25 miles north of Fort Wayne in Auburn, Indiana. (Courtesy of Roger Myers.)

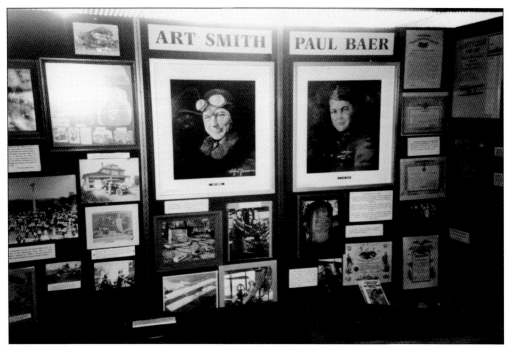

This photograph shows oil portraits of Arthur "Art" Smith (left) and Lt. Paul Frank Baer as they appear in the Greater Fort Wayne Aviation Museum display on the second-level terminal of Fort Wayne International Airport. Fort Wayne's two major aviation pioneers live on through the names of Fort Wayne's two airports. Both of these pilots lost their lives in crashes of their aircraft. (Courtesy of Roger Myers.)

Loren Herber, a teenage modeler, created this replica model of Hangar 38 as it appeared during World War II with assistance from his father. The larger aircraft visible inside the hangar is a model Martin B-26 Marauder. This popular display includes aircraft from the World War II period, including miniature men doing various functions. Hangar 38 was the scene of many USO entertainers from Hollywood. (Courtesy of Roger Myers.)

The Greater Fort Wayne Aviation Museum displays this M-18 Norden bombsight. The Norden bombsight was a top-secret bomb aiming device that facilitated daylight precision bombing of targets in World War II, Korea, and Vietnam. Bombardiers were responsible for maintaining the security of these devices with their lives. The author had personal experience with the use of this device. (Courtesy of Roger Myers.)

This is an externally restored Curtiss OX-5 engine. OX-5 engines were American V-8 liquid-cooled engines manufactured by Curtiss using technology from manufacturing motorcycle engines. They were the first US-designed aircraft engines that were mass produced. They were the standard engines for the Curtiss JN-4 Jenny, because the alternate engines were even less powerful. The Emmert brothers from Howe, Indiana, did the external restoration of this engine. (Courtesy of Roger Myers.)

Four

EXPERIMENTERS
AND ENTREPRENEURS

Flight B Field is the earliest known landing strip in Fort Wayne and was actually nothing more than a field where planes were allowed to land. Flight B Field closed when Sweebrock Airport opened. Sweebrock Airport had hangars and was the location where Transcontinental & Western Airways initiated air service to Fort Wayne in 1930. Guy Means Airport was a private airport located near the present site of Glenbrook Shopping Center. Myers Field was a private airport established by Lester Myers and James "Jim" Kelley and was the center of flight instruction for many years.

In 1925, the Fort Wayne Park Board established Paul Baer Municipal Airport on the north end of the city. It originally had three runways, a large Hangar Two, a passenger terminal, a coffee shop, and other features. Paul Baer Municipal Airport was among the first airports in the United States to use an underground fueling system. Pilots could simply taxi to the fueling location, which was free from above-ground obstructions, open a ground-level door, and refuel their aircraft. Paul Baer Municipal Airport was also among the first airports in the country to be equipped with ground lighting that blanketed the field and facilitated night operations.

When the City of Fort Wayne purchased the buildings and equipment at Paul Baer Field in 1946, some of the general aviation activity moved to the new location. For short period, private aviation was split among Baer Field, Smith Field (formerly Paul Baer Municipal Airport), and Myers Field.

Jim Kelley, one of the founders of Myers Field, was perhaps Fort Wayne's most prominent person in general aviation until his death in 2005. Kelley moved his operations from Myers Field to Paul Baer Field and created Fort Wayne Air Service, which he owned and operated until his death. Fort Wayne Air Service was the leading fixed-base operator (FBO) at Fort Wayne International Airport and offered hangar space, tie-down and parking, flight instruction, aircraft repair, charter service, fuel, and other services to the general aviation community.

James "Jim" Kelley played a major role in Fort Wayne aviation starting in the late 1930s and continuing until his death in October 2005. Born near Decatur, Indiana, in 1918, he was co-owner of Myers Field (with Lester Myers) in southeast Fort Wayne. He provided many war veterans with flight training. When the City of Fort Wayne opened Baer Field in the early 1950s, he moved his operations to that location and operated Kelley Flying Service as an FBO. He went on to own several new-car dealerships throughout the state of Indiana and more in Georgia and Florida. He also owned the Brookwood Golf Course on the north side of Ferguson Road and west of Indiana State Route 1. He was a well-known philanthropist and was one of the main benefactors for the Greater Fort Wayne Aviation Museum. (Courtesy of the Kelley family.)

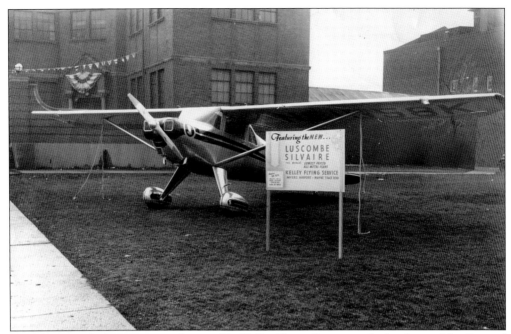

This photograph shows an aircraft owned by Kelley Flying Service parked in front of the General Electric appliance plant in the late 1940s. This display advertised that the Kelley Flying Service had acquired new Luscombe Silvaire aircraft and was used to draw citizens to Myers Field to learn how to fly and purchase an aircraft. (Courtesy of the Kelley family.)

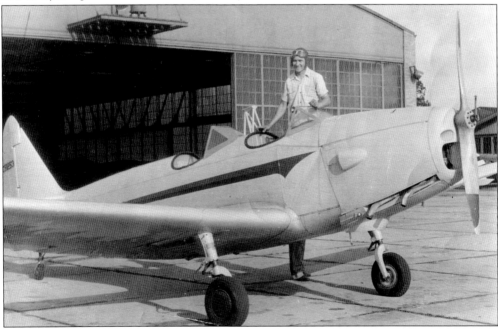

James "Jim" Kelley, who was the founder and owner of Fort Wayne Air Service, shows off his Fairchild PT-19 aircraft at Smith Field in the 1940s. Kelley was among the first to enroll in the Civilian Pilot Training (CPT) program inaugurated by Pres. Franklin Roosevelt and was one of the founders of the Greater Fort Wayne Aviation Museum. (Courtesy of the Kelley family.)

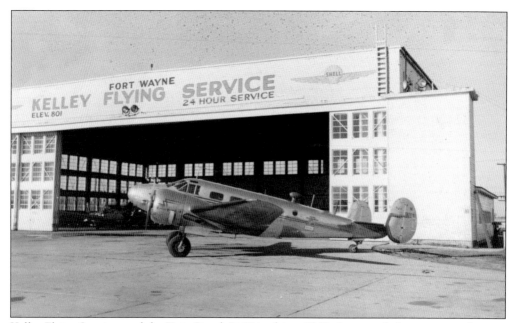

Kelley Flying Service used the Twin Beech D-18 in this c. 1960 photograph for corporate charters from Baer Field. The executives of General Electric, International Harvester, Lincoln National Life Insurance Company, and Central Soya were among the more frequent passengers. The hangar in the background is the former Hangar 38 and is where Kelley operated his business. (Courtesy of the Kelley family.)

James "Jim" Kelley and son Thomas "Tom" Kelley prepare to begin a training flight. Jim Kelley was the founder and owner of Kelley Flying Services. Father and son embraced aviation, auto sales, and golf, succeeding in all areas of these endeavors. James Kelley was among the founders of the Greater Fort Wayne Aviation Museum and a major financial contributor. (Courtesy of the Kelley family.)

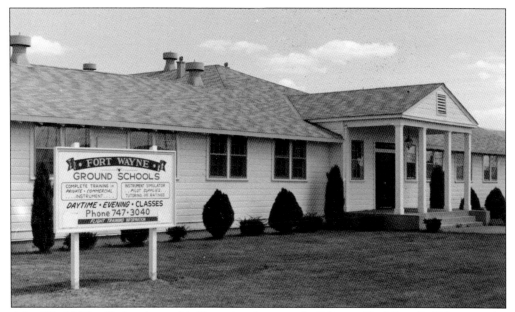

After World War II, the Army Air Corps headquarters building at Paul Baer Field became the location of Fort Wayne Ground Schools. Van Stiffler, a World War II transport pilot, created this school. Over the period of more than 30 years, he gave ground school, flight training, and hot air balloon instruction to several thousand aviation enthusiasts. (Courtesy of Stiffler family.)

Van Stiffler (left), who was founder and owner of Fort Wayne Ground Schools, and an unidentified employee stand behind a table at an open house. Stiffler was a World War II pilot and ferried many aircraft across the Atlantic Ocean. He was well known in the world of aviation and taught thousands, including the author of this book, the art of hot air ballooning. (Courtesy of Roger Myers.)

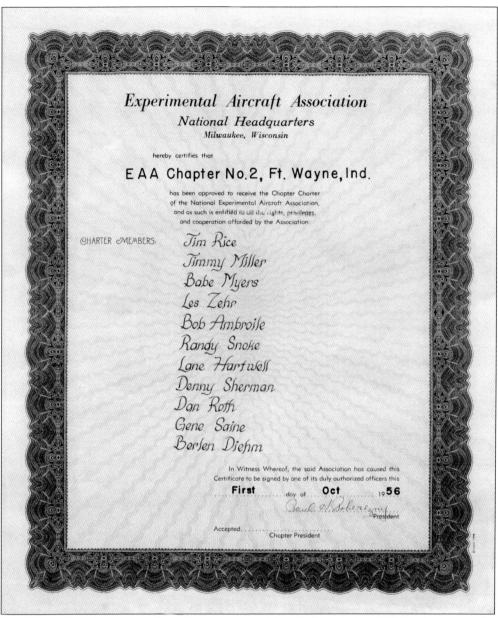

Experimental Aircraft Association
National Headquarters
Milwaukee, Wisconsin

hereby certifies that

EAA Chapter No.2, Ft. Wayne, Ind.

has been approved to receive the Chapter Charter
of the National Experimental Aircraft Association,
and as such is entitled to all the rights, privileges,
and cooperation afforded by the Association.

CHARTER MEMBERS:
Jim Rice
Jimmy Miller
Babe Myers
Les Zehr
Bob Ambroile
Randy Snoke
Lane Hartwell
Denny Sherman
Dan Roth
Gene Saine
Berlen Diehm

In Witness Whereof, the said Association has caused this
Certificate to be signed by one of its duly authorized officers this

First day of **Oct** 19**56**

President

Accepted
Chapter President

Fort Wayne has the second oldest Experimental Aircraft Association (EAA) chapter in the country. In 1953, Paul Poberezny founded the EAA in Milwaukee, Wisconsin; it is now based in Oshkosh, Wisconsin, and hosts the annual weeklong EAA AirVenture Oshkosh, which often attracts more than 10,000 aircraft and 500,000 visitors to the area. The Fort Wayne chapter received its charter in October 1956. Jim Rice, Jimmy Miller, Babe Myers, Les Zehr, Bob Ambroile, Randy Snoke, Lane Hartwell, Denny Sherman, Dan Roth, Gene Saine, and Berlen Diehm were among the founding members. The Fort Wayne chapter is active in the Young Eagles program, which offers youngsters the opportunity to ride in a general aviation craft and experience flying from the pilot's perspective. (Courtesy of Smith Field files.)

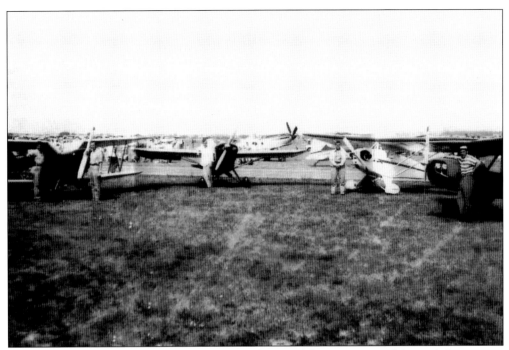

Within two years of its charter, the Fort Wayne chapter of the Experimental Aircraft Association attended what may have been the first national EAA Annual Convention in Milwaukee, Wisconsin, at Curtiss-Wright Field (now Timmerman Field). From left to right, an unidentified bystander and aircraft owners Jim Rice, Thomas "Tom" Miller, Robert "Bob" Ambroile, and Lester Zehr stand near their aircraft in this photograph. (Courtesy of Smith Field files.)

In 1962, the Fort Wayne chapter of the EAA held a meeting at Smith Field. This west-facing photograph shows a surprisingly large crowd of spectators. The unfinished airframe in the foreground is the *Stitz Playboy*, which Lester Zehr built. The handwritten caption in the upper left hand corner reads, "Built by Lester Zehr [in] 1962. Traded to Clem Harvey for Cassel Racer unfinished." (Courtesy of Smith Field files.)

This photograph, taken at Smith Field, depicts a member of the Fort Wayne chapter of the EAA preparing to take some Young Eagles for an introductory flight. A typical Young Eagle flight lasts about 15 minutes and is preceded by a guided preflight walk-around inspection of the aircraft. (Courtesy of Smith Field files.)

This photograph shows an eager and excited young man preparing to enter what appears to be a Piper Cherokee for his Young Eagle flight. Another Young Eagle, who is visible through the rear window, already has her headphones on. This photograph was reportedly taken at a northern Indiana landing strip during a passenger rotation stop. (Courtesy of Smith Field files.)

In 1964, Duane Cole and Dennis Sherman pose in front of Sherman's formula one racer. Cole was a well-known stunt pilot for many years. He accumulated more than 30,000 recorded flight hours. His son, Rolly Cole, lost his life in an aircraft accident while practicing aerobatics for air shows. Sherman operated as an FBO at Baer Field for many years. (Courtesy of the Cole family.)

James Eyster, president of Consolidated Airways at Baer Field, received congratulations from William Piper, president of Piper Aviation, in November 1953 on becoming a Piper dealer at Baer Field. Eyster was the recipient of the 1969 Indiana Aviation Man of the Year Award. Consolidated Airways provided services to general aviation and the commercial airlines. (Courtesy of James Eyster.)

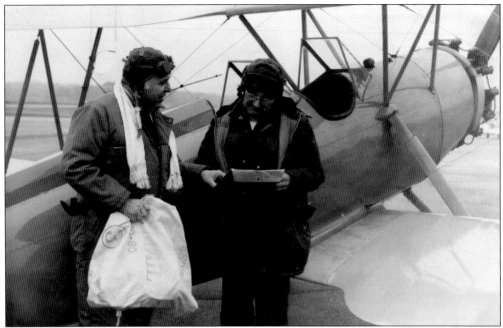

Roger Myers and pilot Edward Shenk flew a special pouch of mail from Fort Wayne's Smith Field to South Bend on December 8, 1980. This flight commemorated the 50th anniversary of airmail service from Fort Wayne, Indiana. The letters bore a special cachet endorsed by the postmasters of both cities. (Courtesy of Max Gray.)

Bowser, Inc., was a well-known manufacturer of pumps in Fort Wayne and built this underground-ramp fueling system at Smith Field. Loyd Pierce (in the dark suit) was a flight instructor. Earl Miller (in the light suit beside the aircraft) observes Claude Davies during fueling operation. The original terminal facility at Baer Field was constructed in 1945 and included a Bowser pump, enabling fueling of aircraft without using a fuel truck. (Courtesy of Fort Wayne International Airport.)

Five

BLACK SNAKES

The 163rd Tactical Fighter Squadron, under the command of Maj. William R. Sefton, was equipped with World War II–vintage North American P-51 Mustang aircraft. They arrived at Baer Field in November 1947 and reported to the 122nd Tactical Fighter Wing at Stout Field near Indianapolis, Indiana. The unit was federally activated during the Korean War.

In 1954, the 122nd Tactical Fighter Wing "Black Snakes" moved from Stout Field to Baer Field and transitioned from P-51 aircraft to Lockheed P-80 Shooting Star jet aircraft. Within two years, the 122nd Tactical Fighter Wing started flying the North American F-86 Sabre aircraft (also called the Sabrejet). In 1958, the fighter wing again transitioned to the Republic F-84F Thunderstreak aircraft. The unit kept the F-84s for over a decade.

The 122nd Tactical Fighter Wing was again activated for the Berlin Crisis of 1961 and served from October 1961 to August 1962 in Chambley, France. By the mid-1960s, the 122nd Tactical Fighter Wing commanded three subordinate tactical fighter groups, which were the 122nd Tactical Fighter Group at Baer Field, the 180th Tactical Fighter Group at Hulman Field in Terre Haute, Indiana, and the 181st Tactical Fighter Group in Toledo, Ohio. The 180th Tactical Fighter Group was soon replaced by the 188th Tactical Fighter Group at Fort Smith, Arkansas, and the 148th Tactical Fighter Group at Kelly Air Force Base, Texas.

The 122nd Tactical Fighter Wing converted to North American F-100 Super Sabre aircraft in 1971; the wing replaced the F-100s with F-4s in 1979 and flew them until 1991, when the General Dynamics F-16 Fighting Falcon aircraft arrived. In 2005, the Base Realignment and Closure Commission (BRAC) made the decision to convert the 122nd Tactical Fighter Wing from the F-16 multi-role fighter aircraft to Fairchild Republic A-10 Thunderbolt II aircraft, which were close air-support aircraft. The transition occurred in 2010-2011.

Today, the Indiana Air National Guard 122nd Tactical Fighter Wing is located on the east side of Fort Wayne International Airport and has over one million square feet of apron space. Subordinate units of the 122nd Tactical Fighter Wing provided humanitarian assistance to Haitian refugees at Naval Station Guantanamo, Cuba, in the 1990s and construction support to a fire station in Taos, New Mexico, and a medical clinic in Pacara, Argentina.

The 122nd Tactical Fighter Wing activated in 1946 at Stout Field in Indianapolis and flew the famous North American P-51 Mustang aircraft. In 1954, the 122nd moved to it present location at Baer Field and converted to the Lockheed P-80 Shooting Star aircraft for a brief period before converting to the North American F-86 Sabre aircraft. In 1958, the unit received the Republic F-84F Thunderstreak aircraft, which remained in the unit until 1971. The North American F-100 Super Sabre aircraft replaced the aging F-84 aircraft. In 1979, the unit changed to the McDonnell Douglas F-4 Phantom II aircraft. Finally, in 1991 the unit received General Dynamics F-16 Fighting Falcon aircraft. In 2011, the unit began conversion to the Fairchild Republic A-10 Thunderbolt II "Warthog" aircraft. The fighter wing was activated in from 1961 yo 1962 for the Berlin Crisis and deployed to Chambley, France. It has also deployed multiple times to the Iraq, Afghanistan, and the Middle East for operations. (Courtesy of Roger Myers.)

Richard McNett receives flying instructions from William R. Sefton at Smith Field in 1947. Sefton was a member of the Indiana Air National Guard and ultimately rose to the rank of brigadier general and retired as the commander of the 122nd Tactical Fighter Wing of the Indiana Air National Guard. (Courtesy of Ellsworth Crick.)

Brig. Gen. William R. Sefton (right), commander of the 122nd Tactical Fighter Wing at Baer Field, consults with the pilots of the famous Air Force Flight Demonstration Squadron, the Thunderbirds, prior to a thrilling aerobatic performance at Baer Field in the mid-1960s. One of the Thunderbird F-100s is visible in the background. (Courtesy of Indiana Air National Guard.)

Civilian guests of the 122nd Tactical Fighter Wing prepare to depart Fort Wayne for a weekend at the Air National Guard base in Alpena, Michigan. This annual event gives civilians the opportunity to see their tax dollars at work. The weekend activities included observing military ceremonies and training activities. Some lucky individuals observed the fighter wing's F-4 fighter-bomber aircraft practicing strafing and low-level attacks. Brig. Gen. Charles "Charlie" Barnes, 122nd Tactical Fighter Wing commander, is on the left. Robert "Bob" Sluyter is near the left, wearing horizontal stripes. Kathy Warren is in the middle of the picture. Ellsworth Crick is on the right side, wearing the plaid shirt. Roger Myers, author, is the distinguished white-haired man near the center of the group. The Convair CV-440 in the background is the aircraft usually assigned to transport the governor of Indiana. (Courtesy of Indiana Air National Guard.)

This photograph shows the entrance point to a free, public open house hosted by the 122nd Tactical Fighter Wing of the Indiana Air National Guard in 1991 celebrating the 50th anniversary of its activation as a unit. This open house featured many static displays and aerial demonstrations. The Experimental Aircraft Association, the Civil Air Patrol, and the Reserve Officer Association also participated. (Courtesy of Roger Myers.)

A Canadian Air Force Hawker Sea Fury visited Baer Field in conjunction with the 50th anniversary of the 122 Tactical Fighter Wing. The Hawker Sea Fury was the replacement for the World War II Supermarine Seafire for aircraft carrier use. The Hawker Sea Fury had a higher cockpit position and much better visibility to allow safer and more reliable aircraft carrier operations. (Courtesy of Roger Myers.)

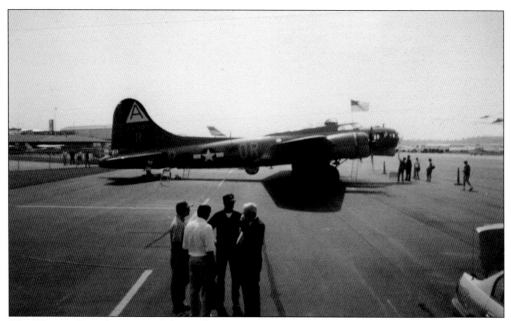

The Wings of Freedom tour of the Collings Foundation visited Baer Field in 1980 with the heavy bomber "Nine-O-Nine" Boeing B-17 Flying Fortress from World War II. Demonstration flights were available for those serious aviation buffs to observe what the aircrews experienced. This event attracted large crowds and remembrances of former Eighth Air Force crewmembers who lived in the Fort Wayne Area. (Courtesy of Roger Myers.)

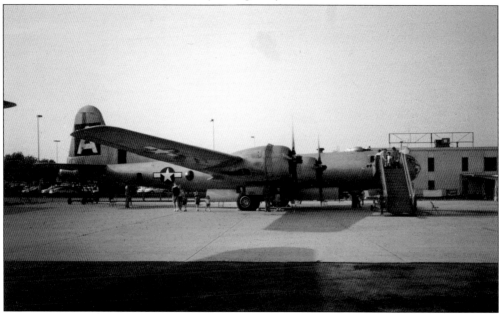

This Boeing B-29 Superfortress aircraft was on static display during the 50th anniversary of the 122nd Tactical Fighter Wing celebration. The Japanese Imperial Army surrendered after the *Enola Gay*, a Boeing B-29 Superfortress bomber, dropped the first strategic atomic bomb on Hiroshima on August 6, 1945, and *Bockscar*, another B-29, dropped the second atomic bomb on Nagasaki on August 9, 1945. (Courtesy of Roger Myers.)

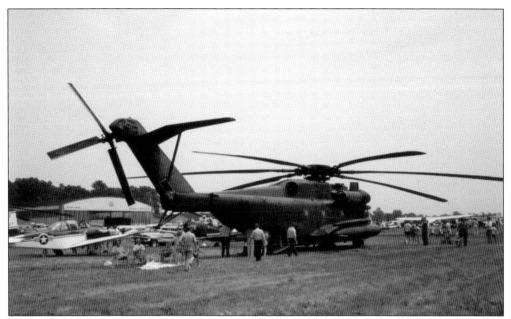

A Sikorsky CH-53 Sea Stallion aircraft is on display at the Smith Field air show in 2001. The CH-53 is the heaviest-lift helicopter in the US military inventory. The Air Force used CH-53 "Super Jollies" aircraft in Vietnam as its primary search-and-rescue aircraft. The US Marines currently uses CH-53E Super Stallions as primary ship-to-shore assault crafts. The US Navy uses MH-53E Sea Dragons for long-range, anti-mine, and heavy-lift missions. (Courtesy of Roger Myers.)

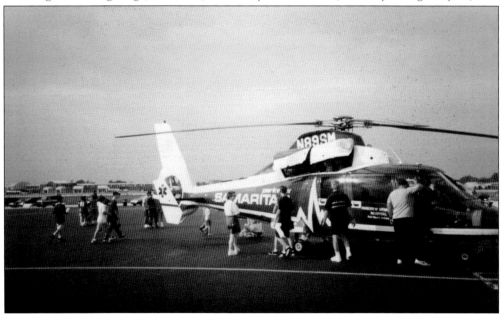

The Aerospatiale AS 365 N2 Dauphin, also called the "Samaritan," was an emergency medical evacuation helicopter that attracted onlookers during a visit to Baer Field. It came during the celebration of the 50th anniversary of Baer Field as an Army air base in 1997. Today, there are two Samaritans. Parkview Hospital in Fort Wayne houses one aircraft, and the airport in Rochester, Indiana, hosts the second aircraft. (Courtesy of Roger Myers.)

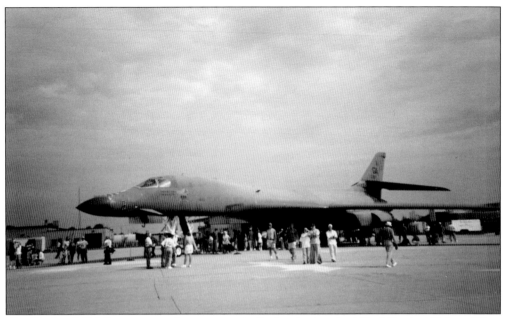

This Rockwell B-1 Lancer aircraft was on static display during the 122nd Tactical Fighter Wing 50th anniversary celebration. The earlier version, the B-1A, was capable of equaling the B-52's bomb load but delivered it at supersonic speeds. Advancements in Soviet technology that were uncovered during the final design of the B-1A convinced the United States to convert the B-1B to being a subsonic bomber capable of low-level penetration. (Courtesy of Roger Myers.)

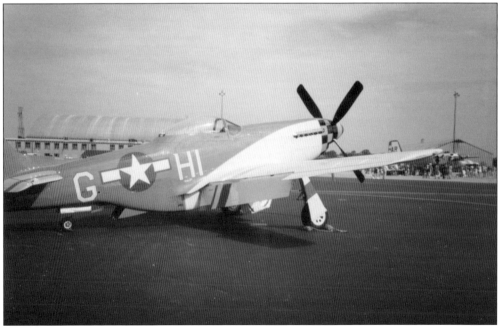

This restored P-51 Mustang from World War II sits at the open house during the celebration of the 50th anniversary of the 122nd Tactical Fighter Wing. It had enough range to escort bombers to and from the target and enough fighter performance to keep the Axis fighters away from Allied bombers. P-51s also served in the Korean War. (Courtesy of Roger Myers.)

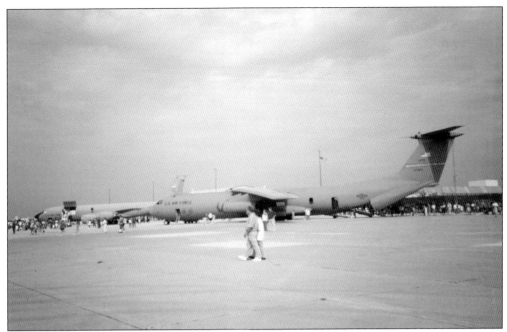

This Lockheed C-141 Starlifter aircraft was on static display. The C-141 was the primary strategic airlift aircraft from the mid-1960s until the introduction of the C-5B and C-17 aircraft. Adding 23 feet of additional length to the fuselage of the 280 aircraft in the fleet provided the equivalent of 90 additional aircraft at a bargain price. (Courtesy of Roger Myers.)

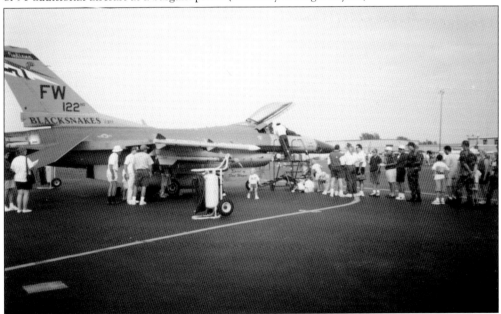

This General Dynamics F-16 Fighting Falcon belonged to the 122nd Tactical Fighter Wing "Black Snakes" and was on display during the celebration of the wing's 50th anniversary. The F-16 is a multi-role fighter aircraft that has seen service in more than 20 nations. The F-16 was notably more nimble than its predecessors. The 122nd Tactical Fighter Wing has deployed its aircraft to Iraq and Afghanistan. (Courtesy of Roger Myers.)

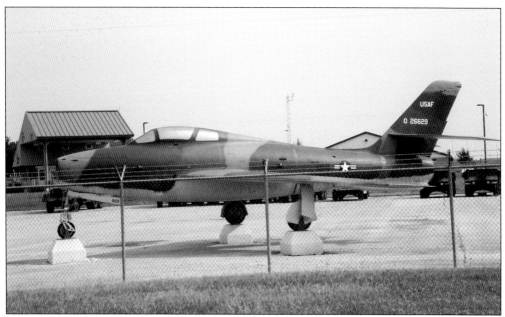

The 122nd Tactical Fighter Wing "Black Snakes" flew F-84 Thunderstreak aircraft from 1958 until 1971, when it received the F-100s. These are the aircraft that the wing deployed to Chambley, France, during the Berlin Crisis of 1961. These F-84s were consistently stable and predictable inside of their performance window but required comparatively long take-off rolls (up to 7,500 feet) on hot days. (Courtesy of Geoffrey Myers.)

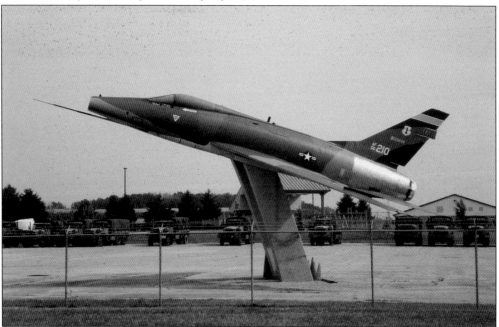

The 122nd Tactical Fighter Wing flew F-100s from 1971 to 1979. These aircraft were disappointing primarily due to their yaw instability in certain attitudes that would quickly caused catastrophic structural failure. In spite of these known flaws, the Air Force Flight Demonstration Squadron, better known as the Thunderbirds, flew F-100s from 1956 to 1968. (Courtesy of Geoffrey Myers.)

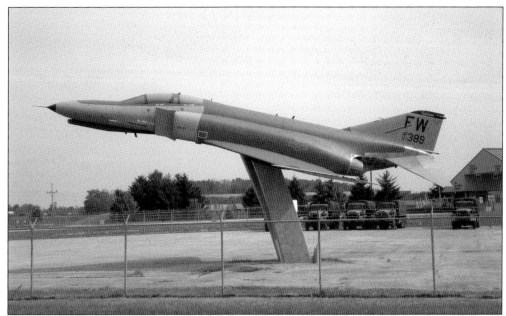

The F-4C in the foreground of this photograph represents the primary aircraft of the 122nd Tactical Fighter Wing from 1979 to 1991. The F-4C entered active-duty service in 1959 and immediately set records for absolute speed and absolute altitude. Although capable of attaining speeds greater than Mach 2, its primary deficiency was the lack of an internal cannon for close air combat. (Courtesy of Geoffrey Myers.)

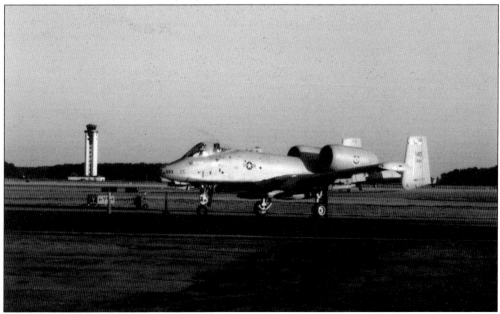

The 122nd Tactical Fighter Wing retired most of the F-16s fighters that had seen service in Iraq and Afghanistan. Pictured here is one of the first Fairchild Republic A-10 Thunderbolt II "Warthogs" that arrived at Baer Field in early 2011. In the distance, the control tower was commissioned in 2005 and was located near Winters Road, standing at 185 feet. The relocated crash, fire, and rescue facility is near the control tower. (Courtesy of Roger Myers.)

Col. David L. Augustine assumed command of the 122nd Tactical Fighter Wing at the Indiana Air National Guard's Fort Wayne Air National Guard Base after serving as the vice commander of the 127th Wing of the Michigan Air National Guard at Selfridge Field. He currently commands about 960 Air National Guard airmen and supports over 140 Army National Guard soldiers. During his almost 30-year military career, Augustine has served in fuel, navigator, weapons officer, reconnaissance, scheduling, maintenance, and command positions. He is a combat veteran with 24 sorties flown in support of Operation Iraqi Freedom. He is a graduate of the Air War College, the Air Command and Staff College, and the Squadron Officer School, and he holds a bachelor of arts degree from Embry-Riddle Aeronautical University. His decorations include the Bronze Star, the Meritorious Service Medal, and the Air Medal. (Courtesy of the Indiana Air National Guard.)

The Greater Fort Wayne Aviation Museum

The Greater Fort Wayne Aviation Museum is the showcase of aviation in the tri-state area (Indiana, Michigan, and Ohio), featuring artifacts from military, commercial, and general aviation. One of the museum's unique holdings is the scrapbook that Arthur "Art" Smith's mother assembled during Smith's daring exhibition flying tours. It also highlights Paul Frank Baer, the Fort Wayne native who was the first American ace of World War I. A Norden bombsight that was used in World War II, Korea, and Vietnam is also displayed. The largest item on display in its own case is an externally restored Curtiss OX-5 engine that is similar to those used in the famous Curtiss JN-4 Jenny aircraft.

The museum is located on the secured side of the Lt. Paul Frank Baer terminal at Fort Wayne International Airport. Current security policies limit access to the museum, and only passengers who have cleared the Transportation Security Administration checkpoint or those on an official museum tour can enter the facility. Admission is free.

Tours are free and last about 90 minutes. Reservations must be made in advance and can be scheduled by calling 260-747-4146 (extension 439) during regular business hours. Tours can be tailored to fit the needs or interests of a group but are best suited for ages 6 and over. Teachers and leaders of organizations are encouraged to set up customized tours.

Tours are available 365 days per year from 6:00 a.m. to 7:00 p.m.

Additional and current information is always available at the museum's website, *Aviation Museum, Baer Field*, which is found at www.fwairport.com/air-museum.aspx.

DISCOVER THOUSANDS OF LOCAL HISTORY BOOKS
FEATURING MILLIONS OF VINTAGE IMAGES

Arcadia Publishing, the leading local history publisher in the United States, is committed to making history accessible and meaningful through publishing books that celebrate and preserve the heritage of America's people and places.

Find more books like this at
www.arcadiapublishing.com

Search for your hometown history, your old stomping grounds, and even your favorite sports team.

Consistent with our mission to preserve history on a local level, this book was printed in South Carolina on American-made paper and manufactured entirely in the United States. Products carrying the accredited Forest Stewardship Council (FSC) label are printed on 100 percent FSC-certified paper.

MADE IN THE USA